TRURO LIGHT

A Journey from Ocean to Bay

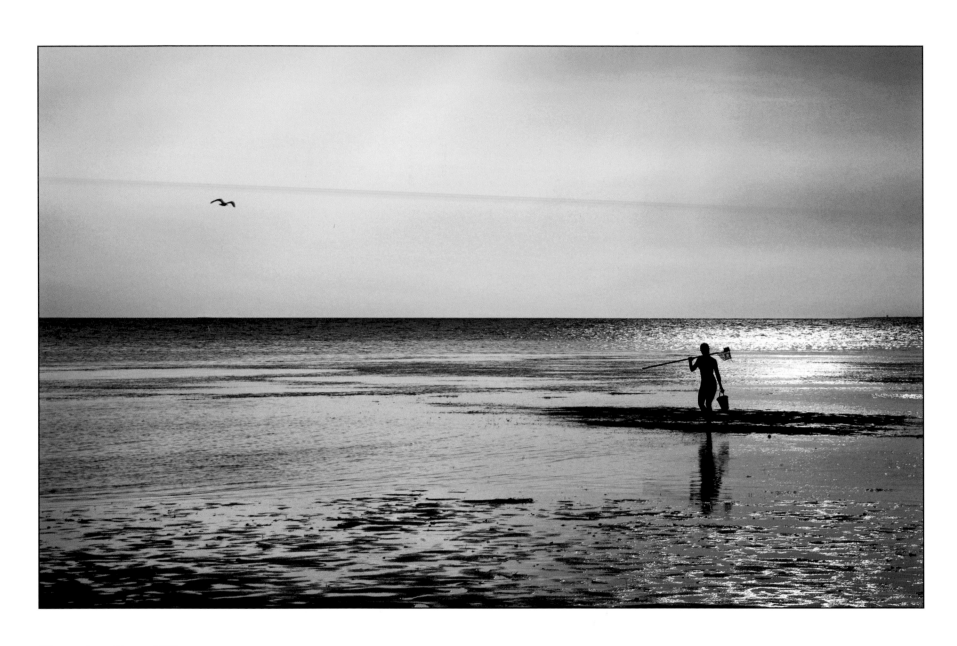

Clamming, Corn Hill

TRURO LIGHT

A Journey from Ocean to Bay

PHOTOGRAPHS BY

JOSEPH SCHUYLER

FOREWORD BY

ROWLAND SCHERMAN

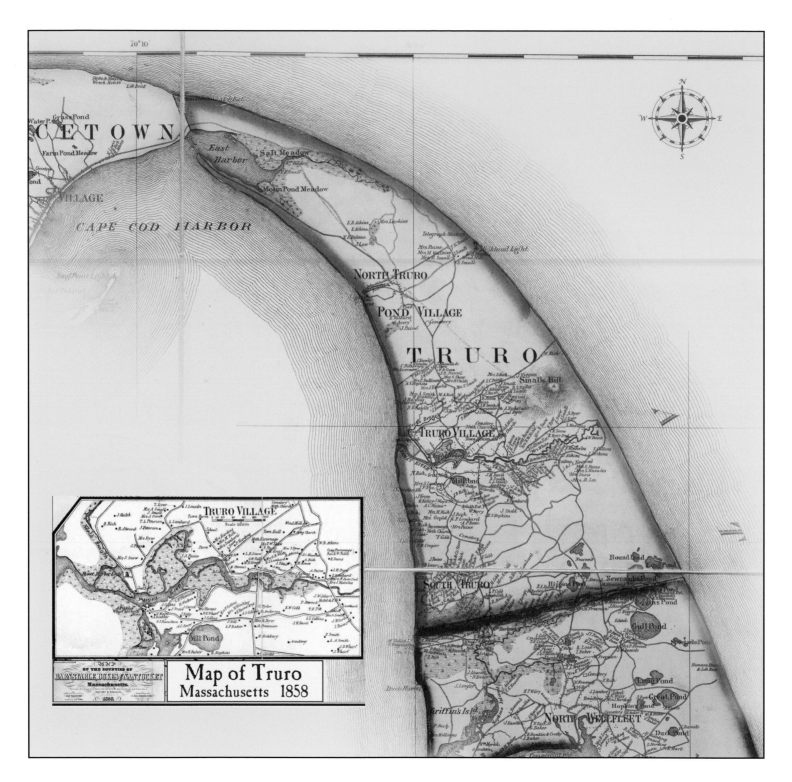

"1858 Map of the Counties of Barnstable, Dukes and Nantucket, Massachusetts" by Henry F. Walling (detail)

CONTENTS

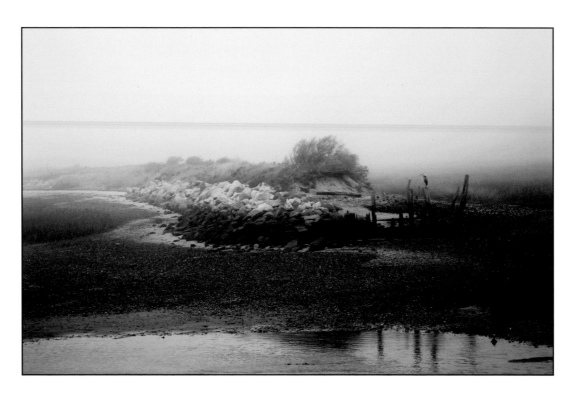

Old Railroad Trestle

ARTIST'S STATEMENT

It was as a young photographer, in the 1970s, that I first encountered the transcendent beauty of Truro. I had always spent summers in New York's Adirondack Mountains, a place of pristine lakes and dense forests redolent of damp earth and pine. By contrast, the subtle landscape of the Cape was a revelation to me: soft light, open skies, endless ocean vistas, scrub pines, clean breezes and drenching sunshine offered a completely new perspective.

As a private student of the photographer Minor White, I was steeped in the concept of photographing a subject not only for itself, but also for "what else it is"; and I found in Truro endless subjects that had these multiple dimensions. Then, I discovered the work of the 19th century British photographer P.H. Emerson, whose serene, subtle images of Britain's waterways resonated with me. Writing in her introduction to a monograph of Emerson's work, Nancy Newhall remarked:

"…he was probably the first true photographer-poet—the first to whom the beauty of the image on the ground glass, the moods and emotions it aroused, were more important than the subject, however important in itself." *

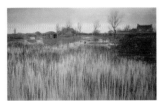

A Rushy Shore P.H. Emerson

Emerson's and White's views of photography greatly aligned with my own, and I found the Truro landscape perfect for exploring photography as poetry, evoking for the viewer the feelings I experienced while making the images, and seeing a subject for "what else it is". Thus began a decades-long project of photographing Truro. When I came to pore over the years of collected images in preparing this book, I discovered that it was the light in Truro that revealed so many layers of meaning and feeling. Thus the title: *Truro Light*.

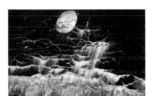

Moon and Wall Encrustations
Minor White

I have organized the book as a traveler might experience Truro: as a journey from ocean to bay, following the path of the Pamet River. The Atlantic Ocean shoreline in the east, where the journey begins, is overwhelming in its vastness of scale and relentless sounds of rolling waves. The marsh and the river are a land of secrets, hidden by high tide, then revealed as the water recedes. These places are remarkable for their solitude and quiet. Journeying inland, the pines—inelegant craggy survivors—are bent whatever way the wind blows them. Pond life is a kaleidoscope of color and shapes. Seen in detail, it is a world animated by light and shadow. Moving west, the jewel-like Pamet Harbor, with boats scattered about in wonderful compositions, is especially appealing at sunset, and in those rare moments when the tide neither ebbs nor flows and the wind departs. In those moments time seems suspended. The journey ends at Cape Cod Bay, where the sun sparkles across the water all the way to the horizon. One is immersed in sky and textured water stretching from Provincetown to Plymouth.

Whatever I photograph, my goal is to record the feeling of being in the midst of the experience. I want the viewer to be able to step inside an image, walk around, feel the chill of the water, the coarse sand, and the burning sun. For those who are familiar with Truro, I hope my images evoke the memory of a beloved place, and the opportunity to re-experience some of your own insights and discoveries. For those new to these environs, my goal is for you to be able to experience for yourself the sense of this remarkable place.

*Nancy Newhall, *P.H. Emerson: His Life and the Fight for Photography as a Fine Art.* (New York: Aperture, Inc., 1975), 4.

Photographs copyright © 2015 Joseph Schuyler

Copyright in individual photographs held by Joseph Schuyler

.

All rights reserved. No part of this book may be reproduced in any form or by any electronic or mechanical means,
including information storage and retrieval systems, without permission in writing from the publisher
except by a reviewer who may quote brief passages in a review.

First Edition

Library of Congress Cataloging-in-Publication Data

Schuyler, Joseph

Truro: photography and commentary/by Joseph Schuyler —1st ed.

116 pages, 11 x 12 inches

ISBN 9780996076708

Library of Congress Control Number 2014957457

1. Truro—Cape Cod—Massachusetts—Photography—Landscapes
Book Design by Charles Fields and Gail Fields
Color Consultant Glenn Bassett

Front Cover: Sunrise, Ballston Beach
Back Cover: Low Tide, Head of the Meadow

Body text and captions set in Bell MT
Title page and chapter headings set in Trajan

∞ This book is printed on acid-free paper meeting the requirements of the American National Standard for
Permanence of Paper for Printed Library Materials.

Printed in South Korea

PO Box 564 North Truro, MA 02652
508.487.5901 www.charlesfields.net

FOREWORD

"The sun once more touched the fields,
Mounting to heaven from the fair flowing
Deep-running Ocean."
—Henry David Thoreau

Thoreau wrote those words in his Cape Cod journal while visiting Highland Light in Truro, in 1846. Further along in his essay he correctly surmised that Cape Cod itself would become less of a whaling port or a farming community as pioneers pushed ever westward in search of arable farmland, and would become "a showplace of the seaside for all New England."

For many, the unspoiled town of Truro has represented the essence of the Cape, long after Thoreau's prediction, and well before the landmark decision by John F. Kennedy to make the region part of the National Seashore—sacrosanct against unruly development. It is from here that photographer Joseph Schuyler draws his rich color scheme in *Truro Light*.

For my family, Truro has always been thus. For (what now seems) an incredibly paltry sum, our uncle, a LIFE photographer, bought a brace of cabins and a few acres on a pond in Truro. This was in 1936. The larger cabin was named Camp Happytimes, and the smaller was Camp Crappytimes. My sister, my brother and I visited this magical paradise every summer for a month or so, every year, for decades. Like so many current residents of Cape Cod, I am a "washed ashore"— one who recalls how great were the Cape memories of his youth that when the time came to retire, he relocates to the place from where all that remembered fun emanated. Not much, thankfully, has changed: the majestic dunes of Ballston Beach seem smaller now, or is it because we are taller? The Pamet Roads are no longer connected due to an ocean breach in 1991. Our favorite hamburger joint is now a real estate office. Snowie's Garage is long gone, and the Blacksmith Shop restaurant is now called Blackfish. That's about it.

There is a mystery in the quality of light that bathes Truro. It is cleansed and somehow transformed to diamond clarity by the proximity of ocean and bay to a slender landmass of dune, marsh and forest less than a mile wide, constantly refreshed by breezes. Of course, this little town cannot claim exclusivity of the visual acuity of Cape light. Artists and writers have migrated here in growing numbers since the early years of the 20th century, and all have testified, either with brush or pen or lens, that they were smitten, and inspired, by it. There are multitudes of Cape Cod picture books. Sometimes I quip that there are 12,000 precise locations on the Cape to make swell pictures, and there are 19,000 photographers out there making them! *Truro Light*, I feel, rises a good way above the masses. Schuyler's pictures are structured, consistent. They complement each other. Among my favorites in this book are his close-ups of the pond flora and the near-abstract images of light reflections in the water. There are scores of other scenes herein that deserve real scrutiny as they all have a discipline and compositional strength that one will surely recognize as masterful.

Perhaps one purpose of Joseph Schuyler's *Truro Light* was to document for modern readers a view to realize how prescient were the words of Thoreau, and how effective was JFK's plan to keep it that way. More probably his images are a personal, visual love poem to Truro, a place he clearly loves; and his work shows it. Importantly, for me, *Truro Light* beautifully refreshes those memories I hold so dear and why I am glad my friend Charles Fields asked me to write this introduction.

—Rowland Scherman

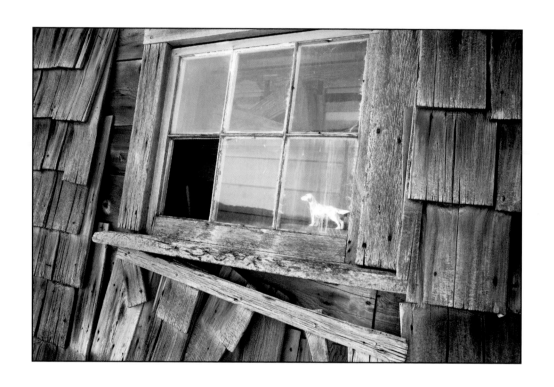

OCEANSIDE

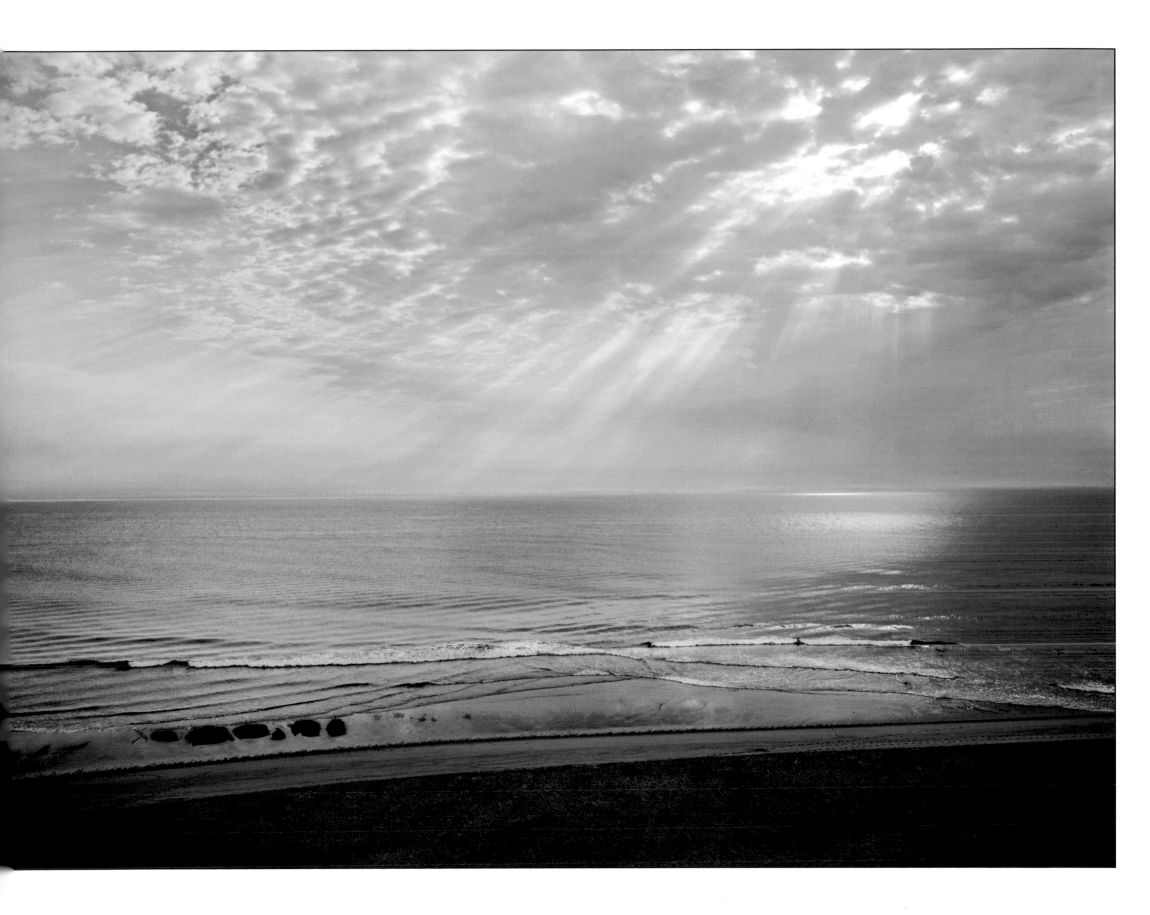

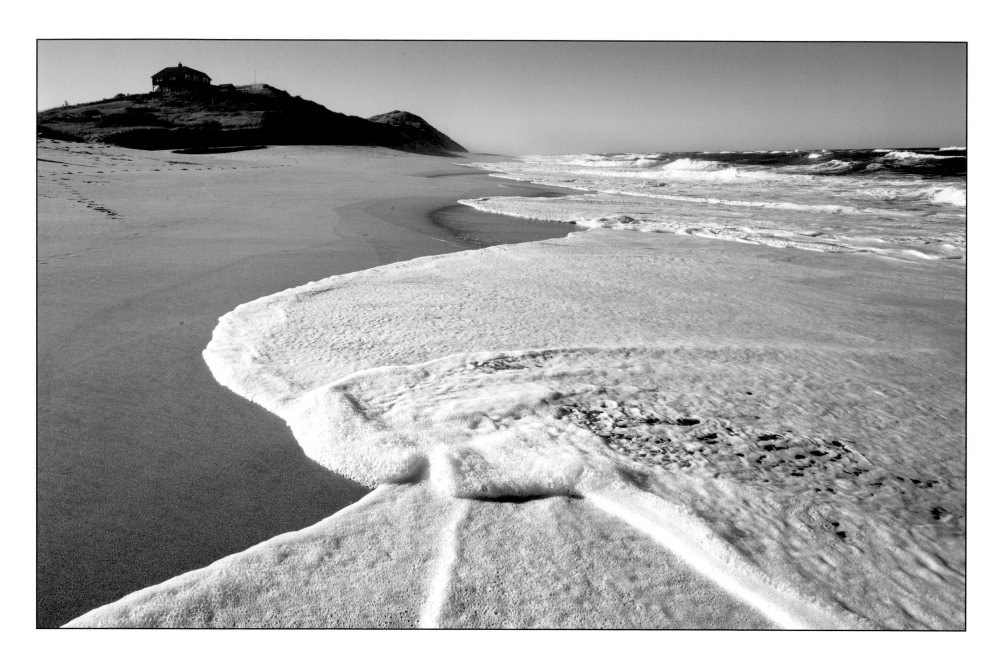

Surf, Ballston Beach

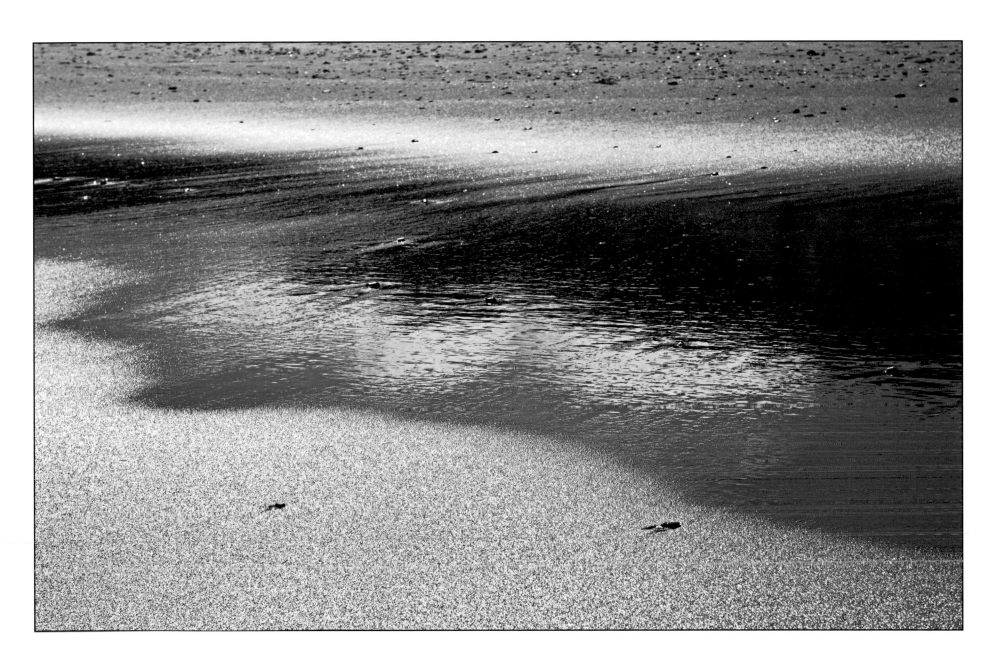

Cloud Reflection, Ballston Beach

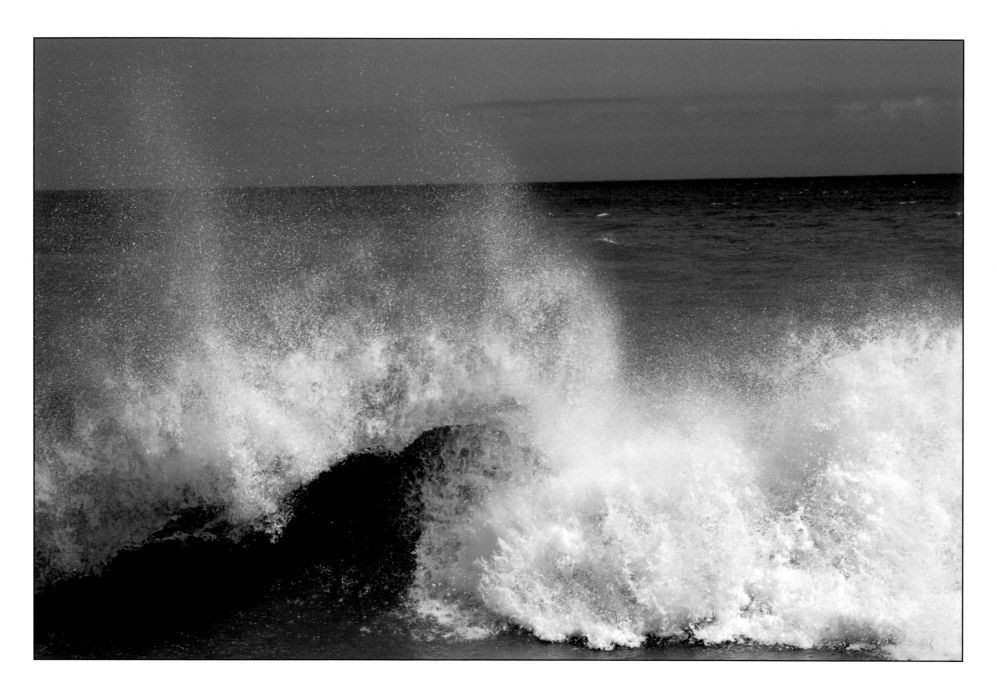

Breaking Wave

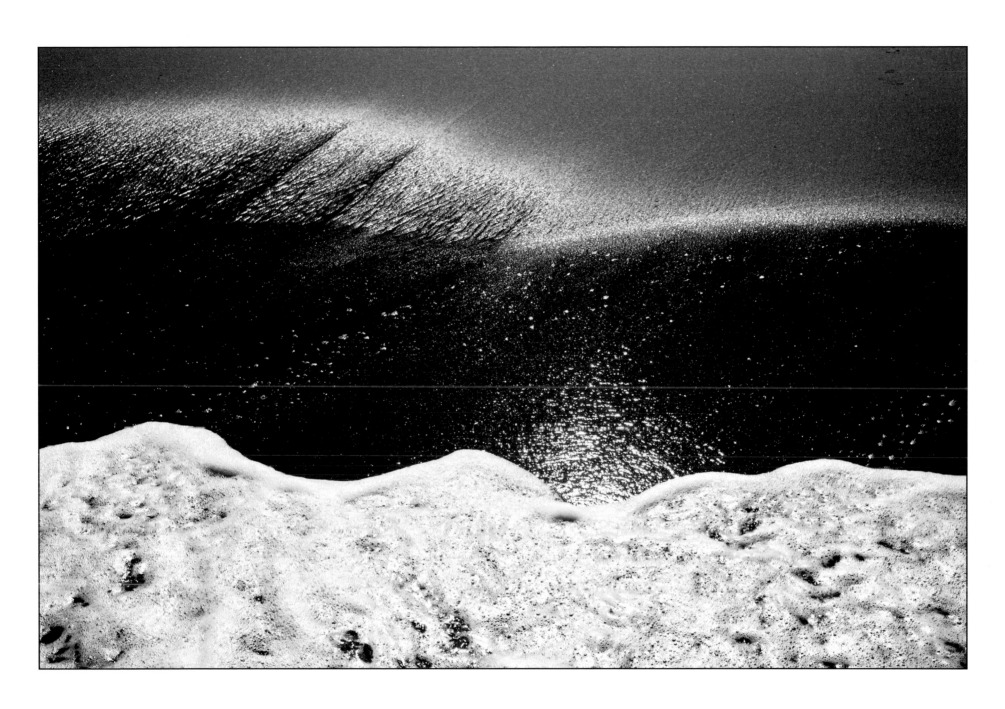

Receding Surf

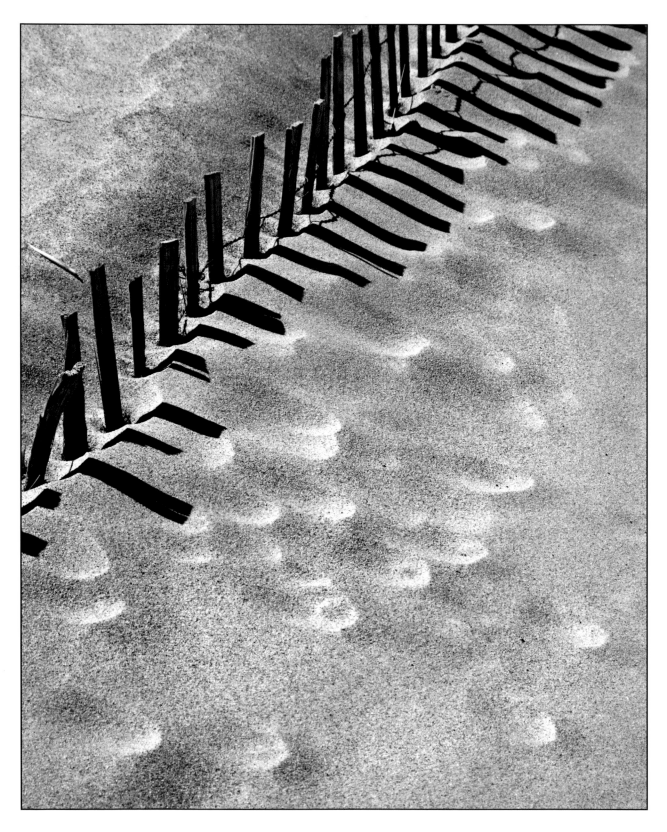

Dune Fence

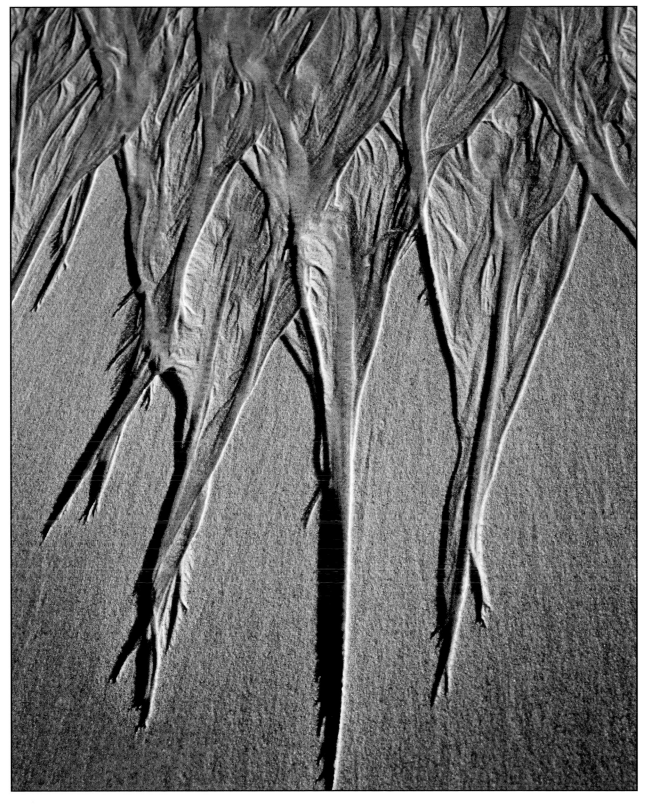

Sand Trees

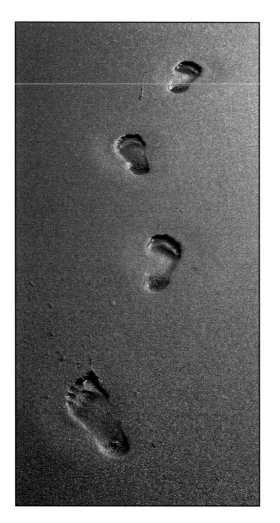

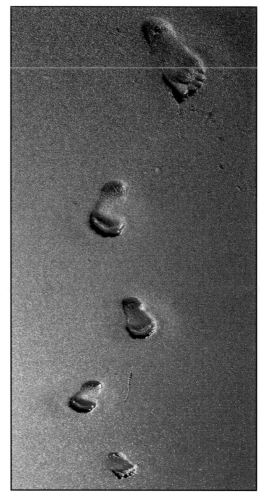

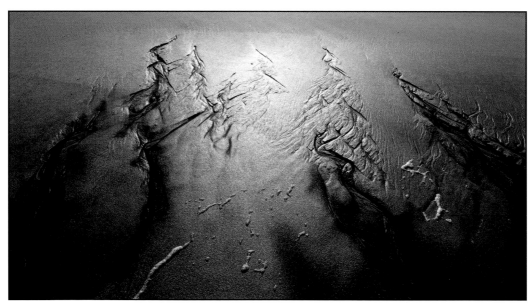

Impressions

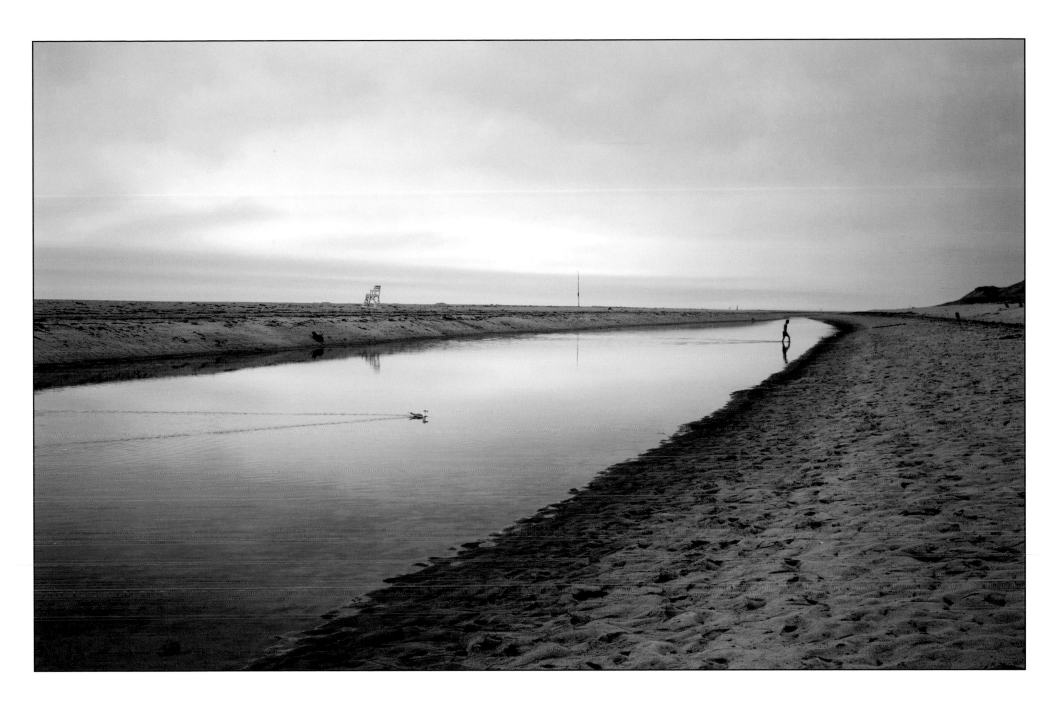

Head of the Meadow

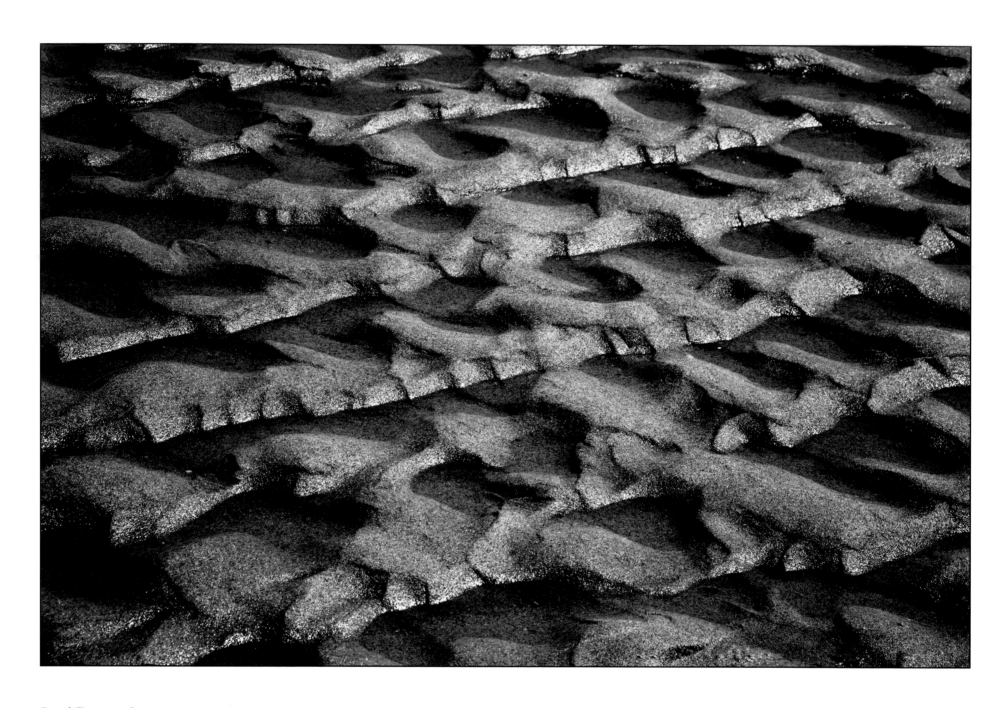

Sand Pattern I

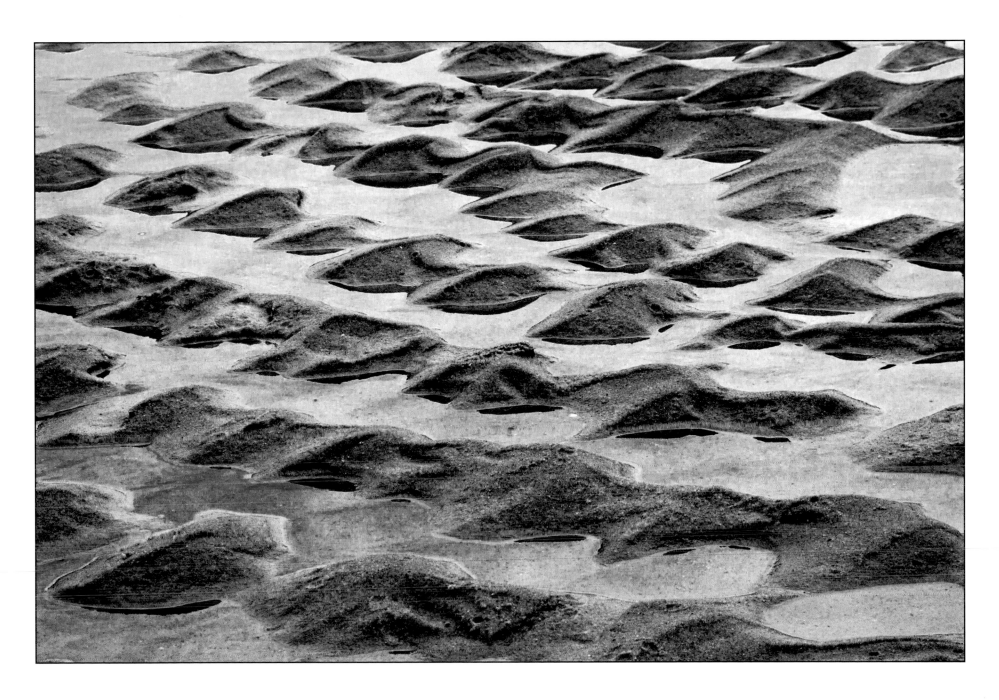

Sand Pattern II

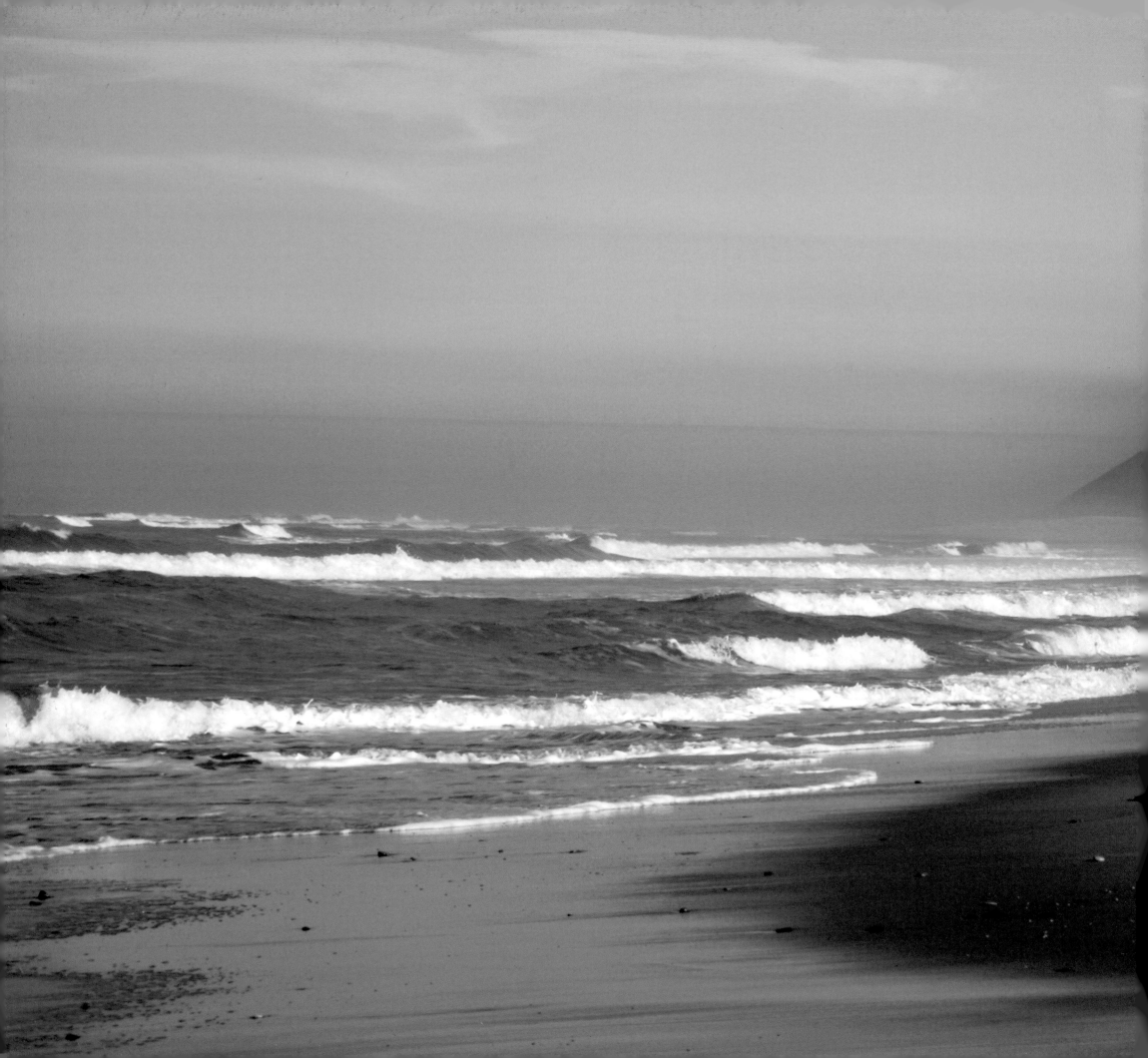

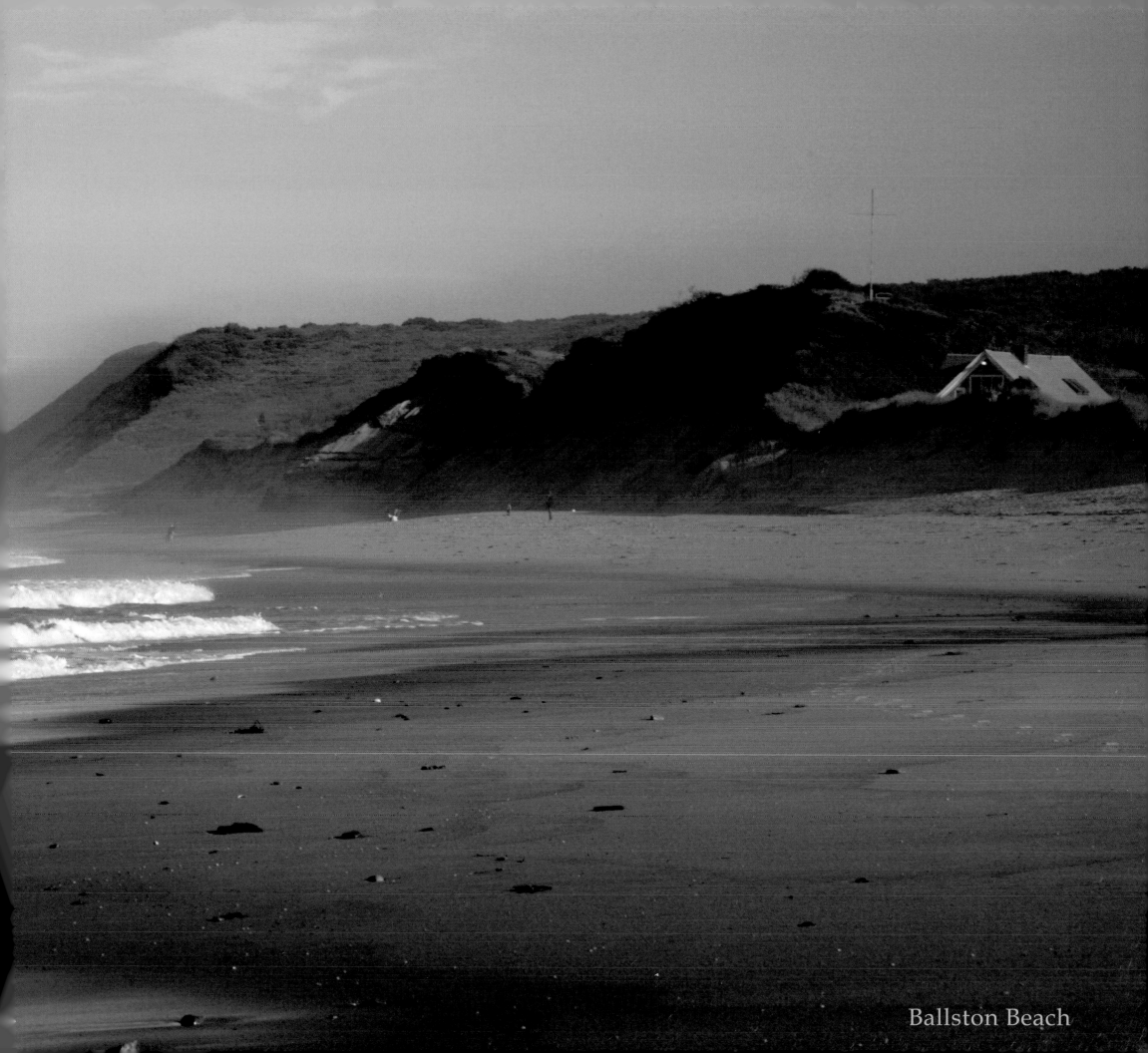

Ballston Beach

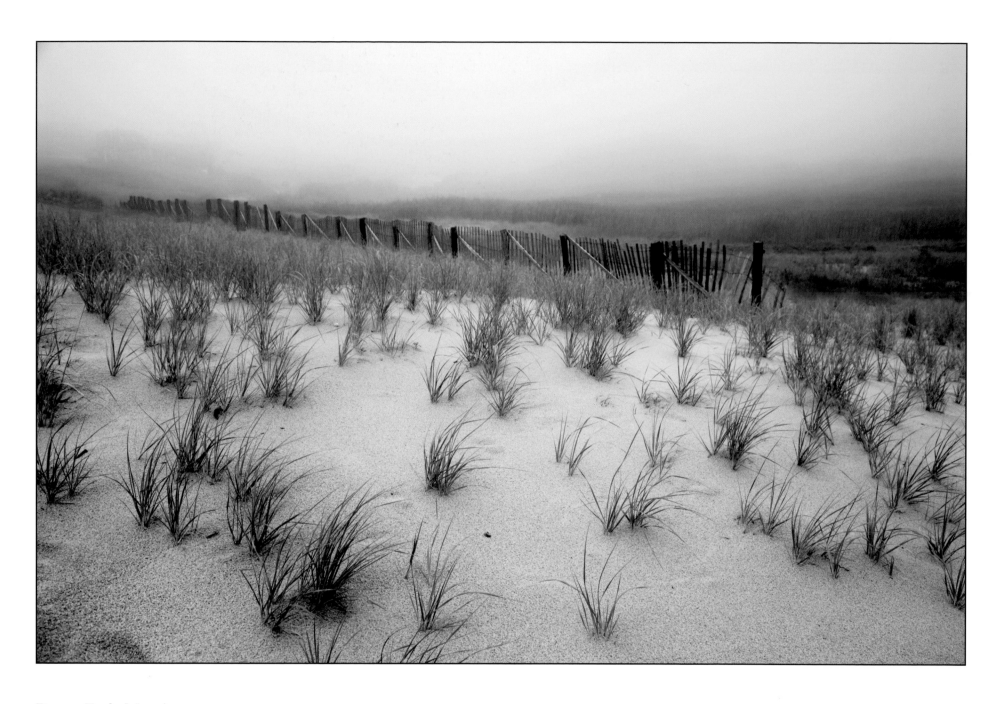

Dunes, Early Morning

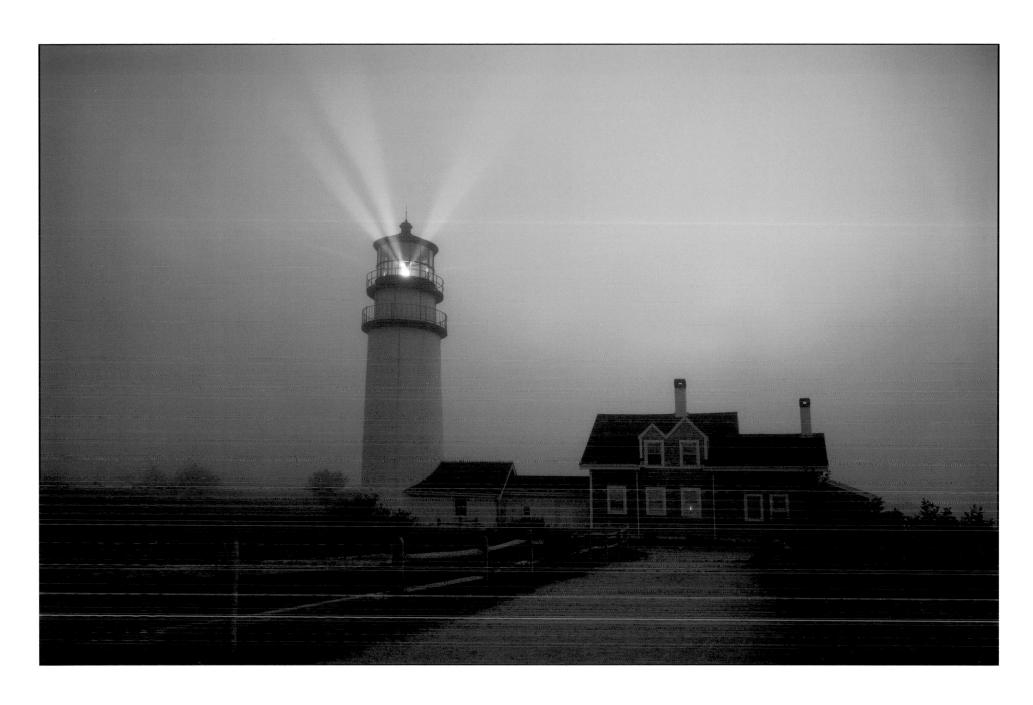

Highland Light

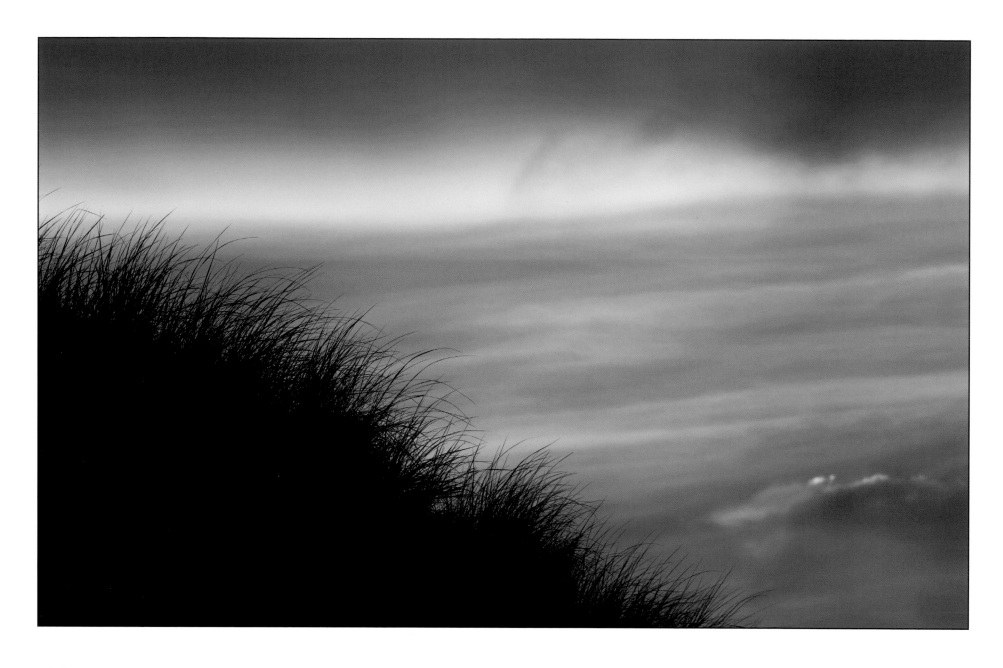

High Dune Grasses

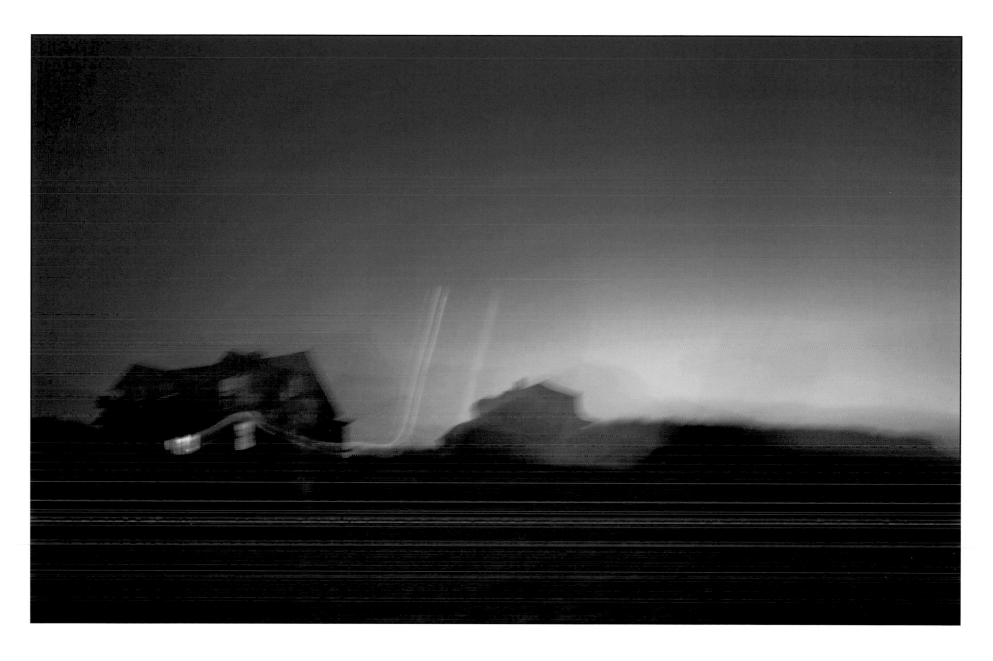

House at Night

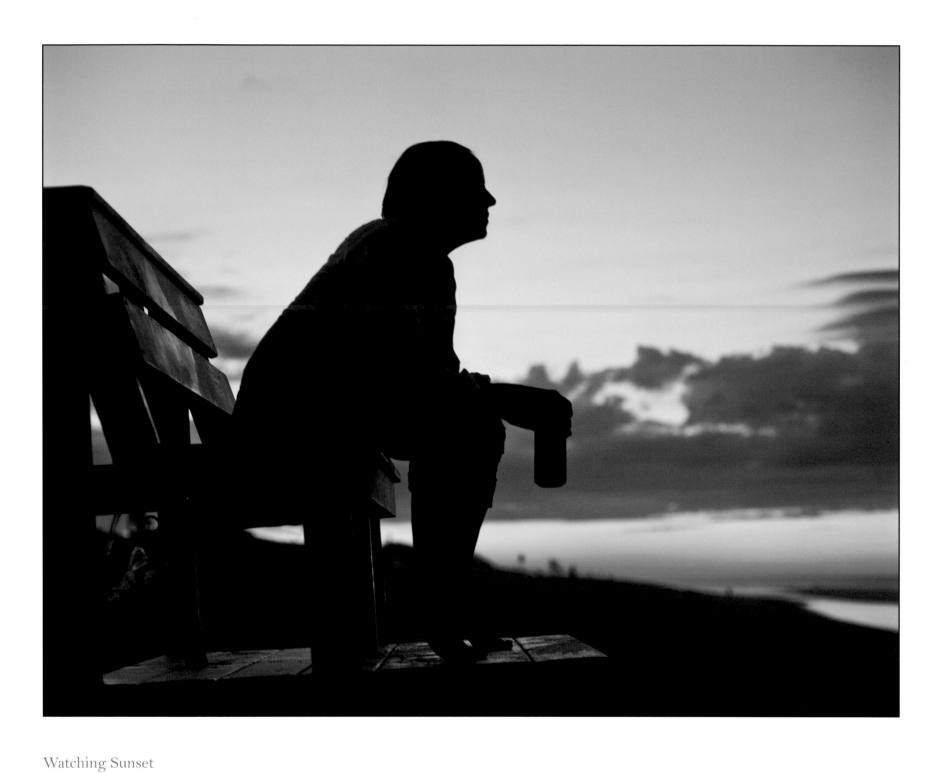

Watching Sunset

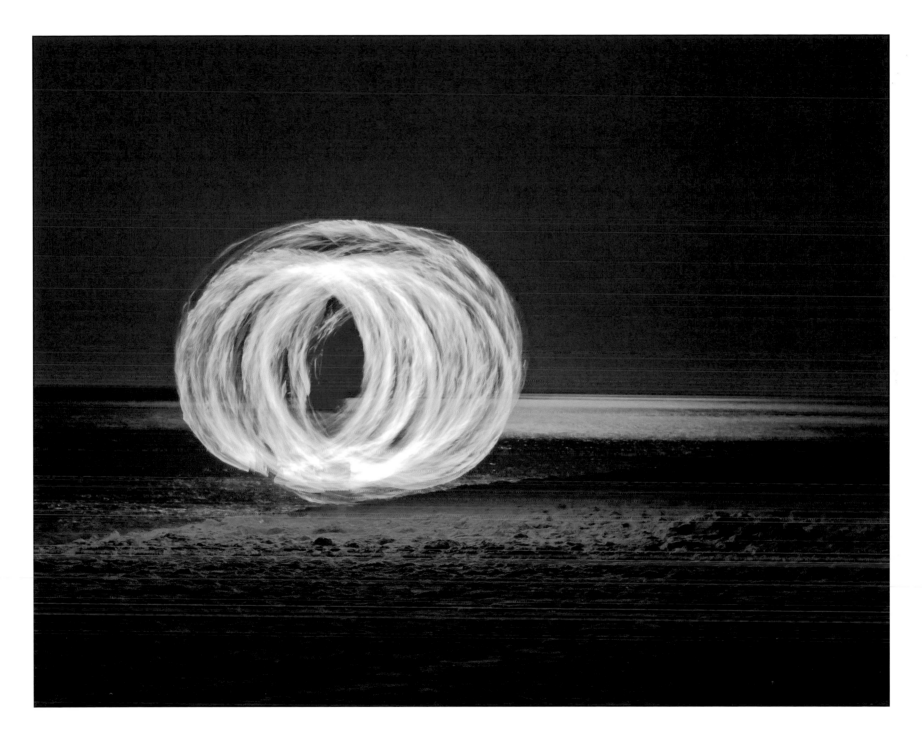

Ball of Fire

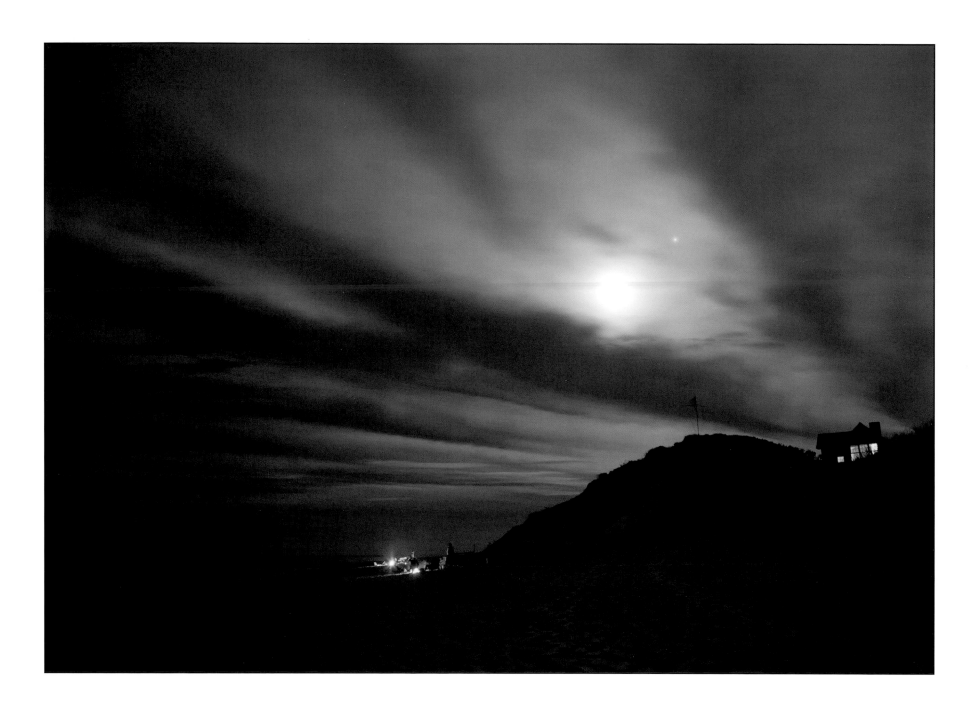

Ballston Beach Fire

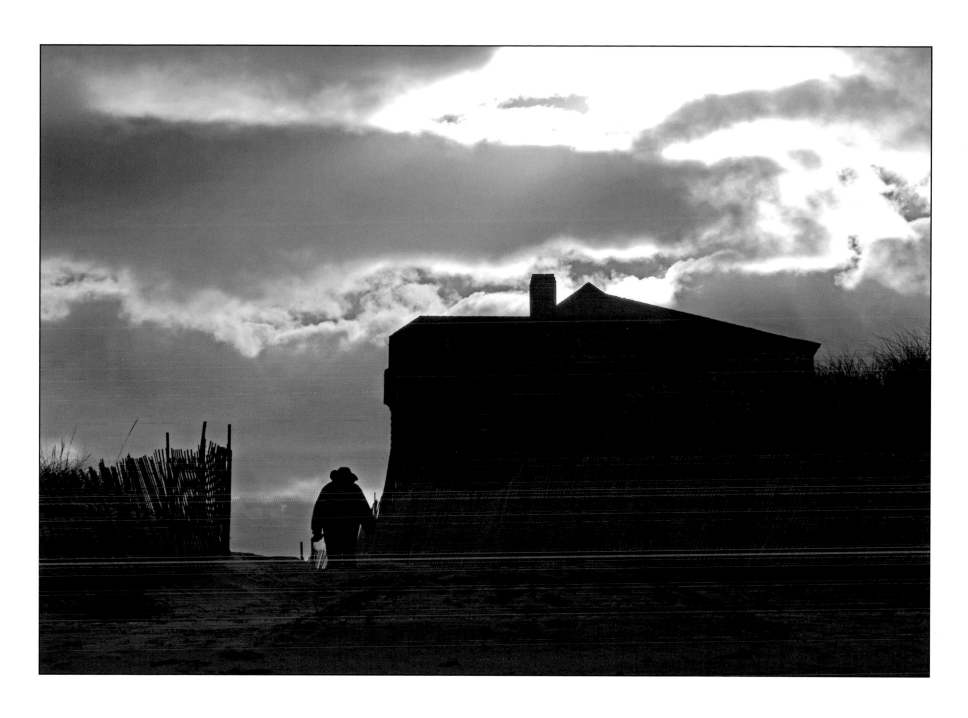

Going Home

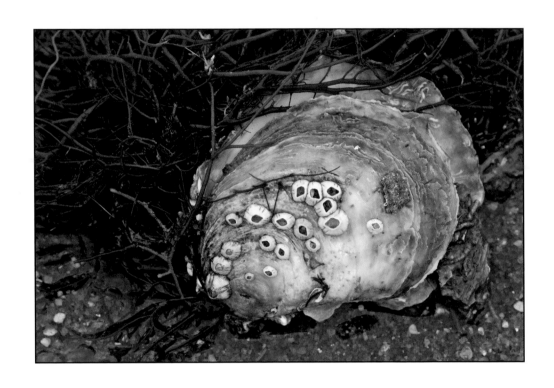

THE MARSH AND THE RIVER

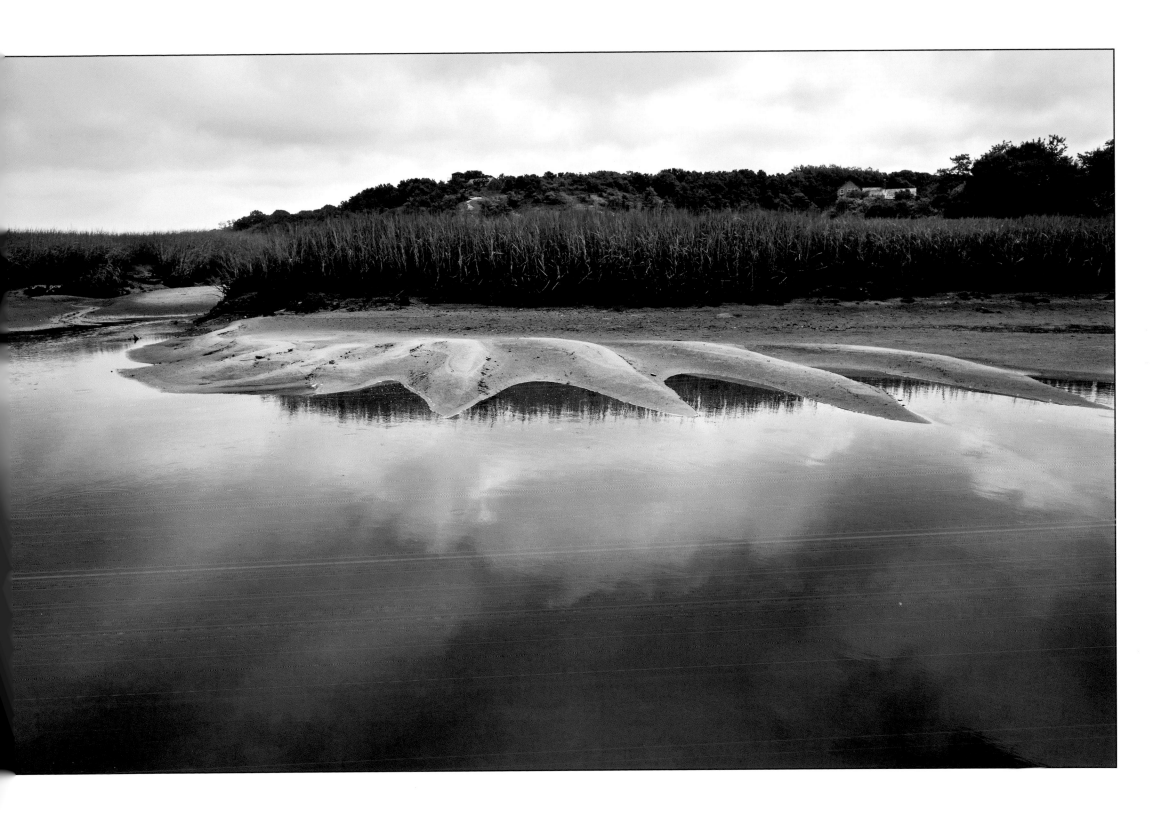

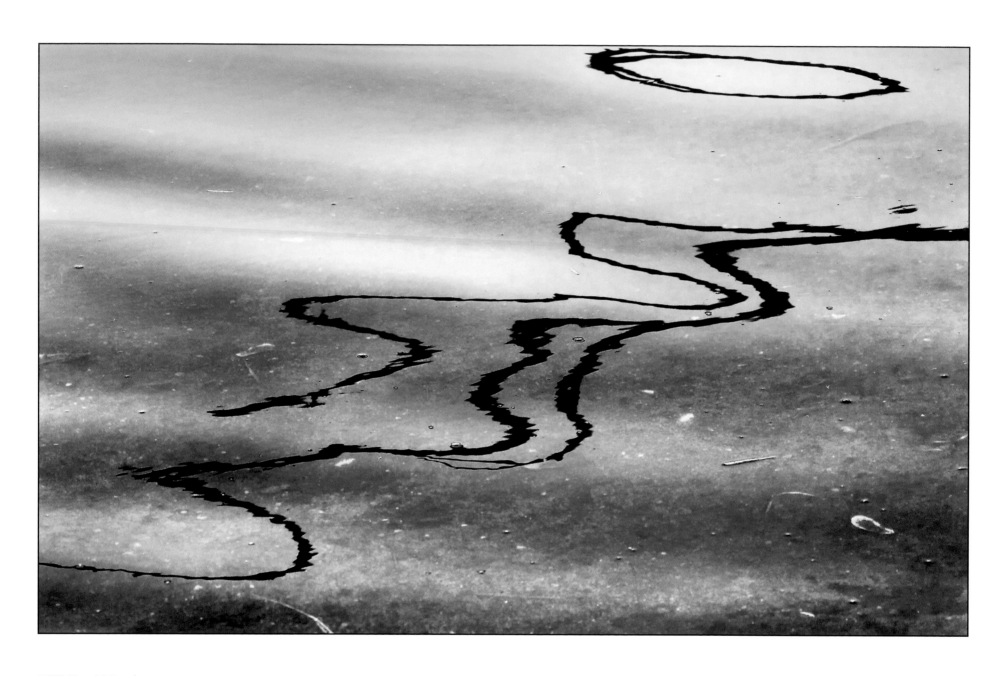

Mill Pond Marsh

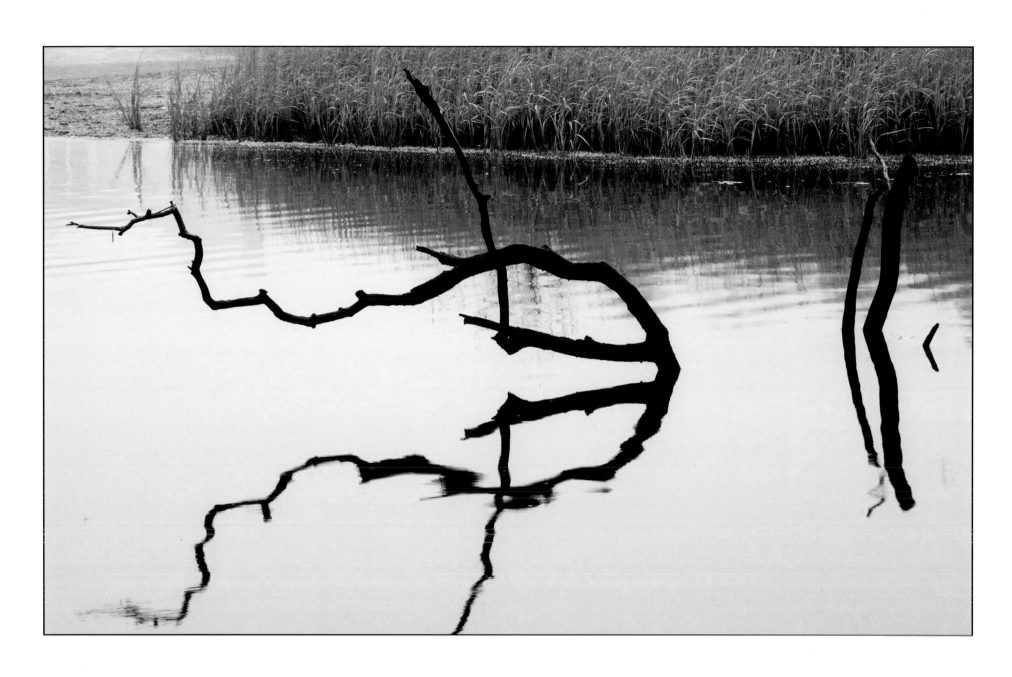

Reflected Branch

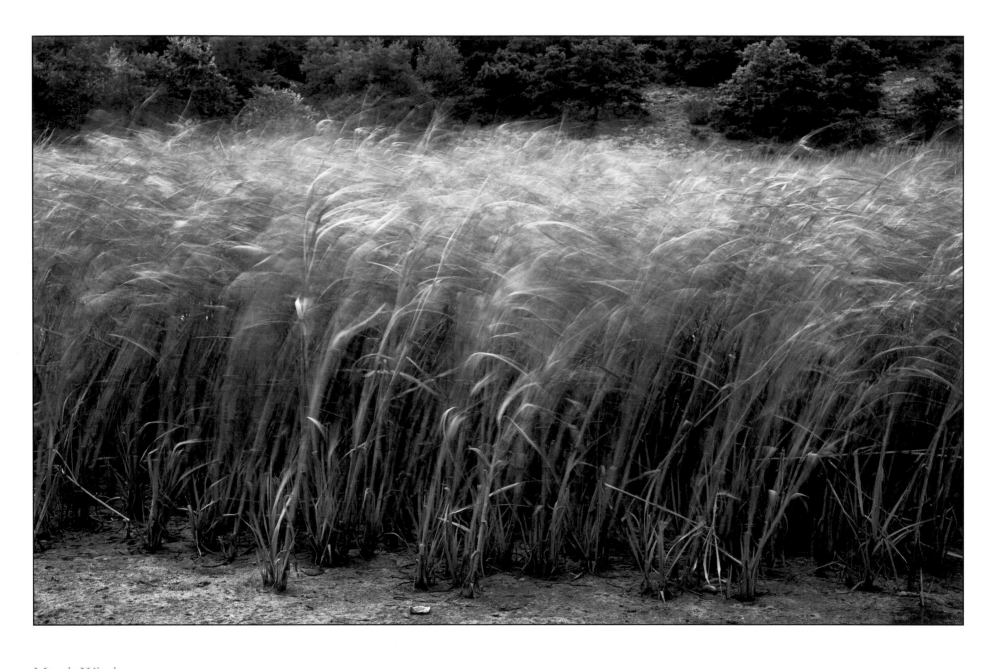

Marsh Wind

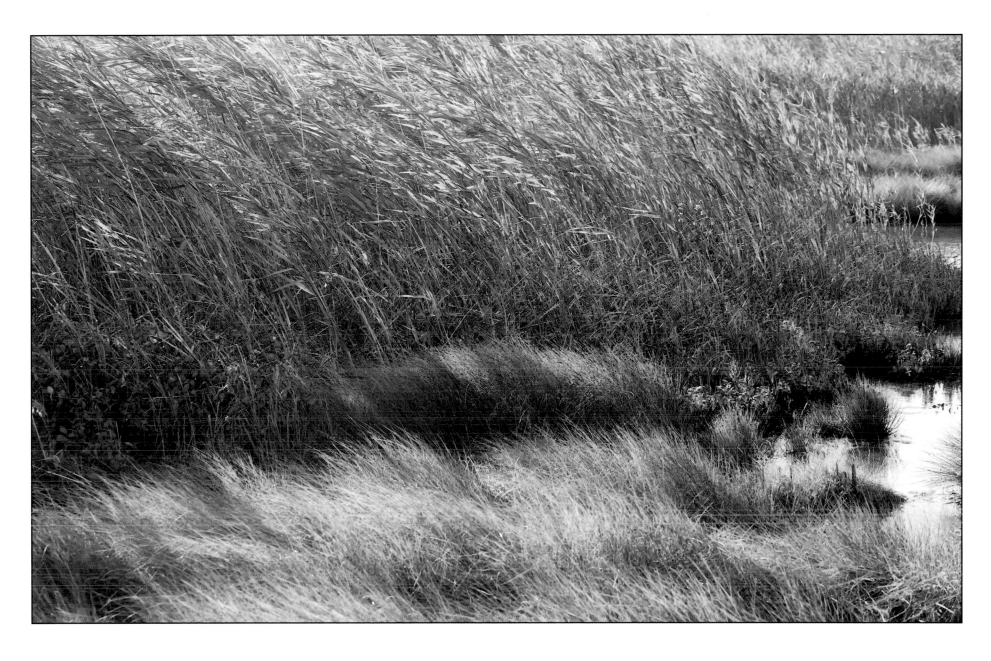

East Pamet Marsh Grass

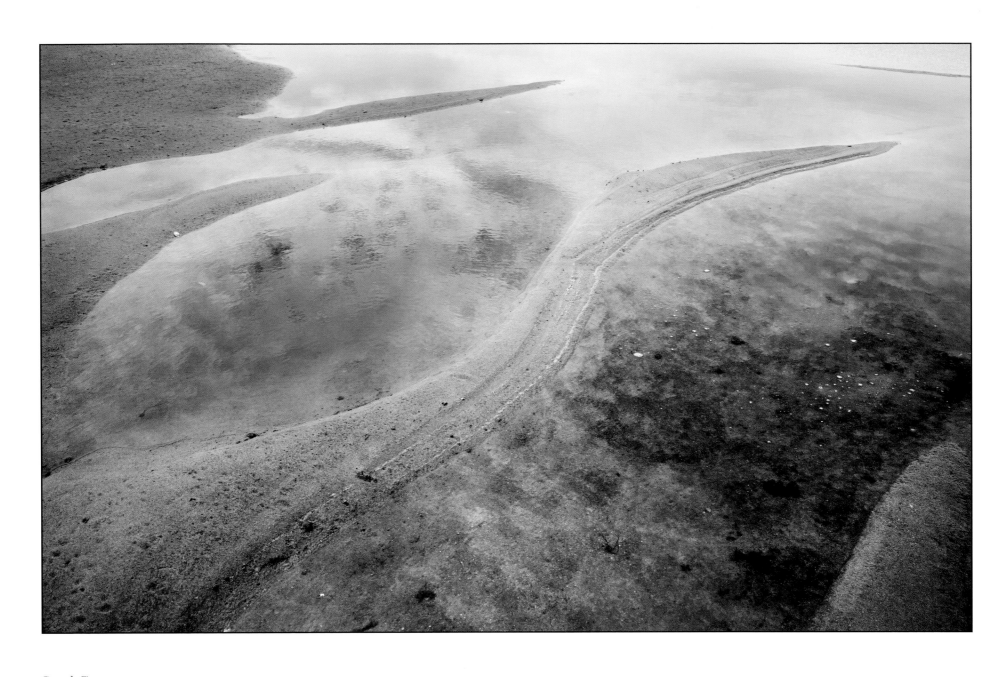

Sand Crane

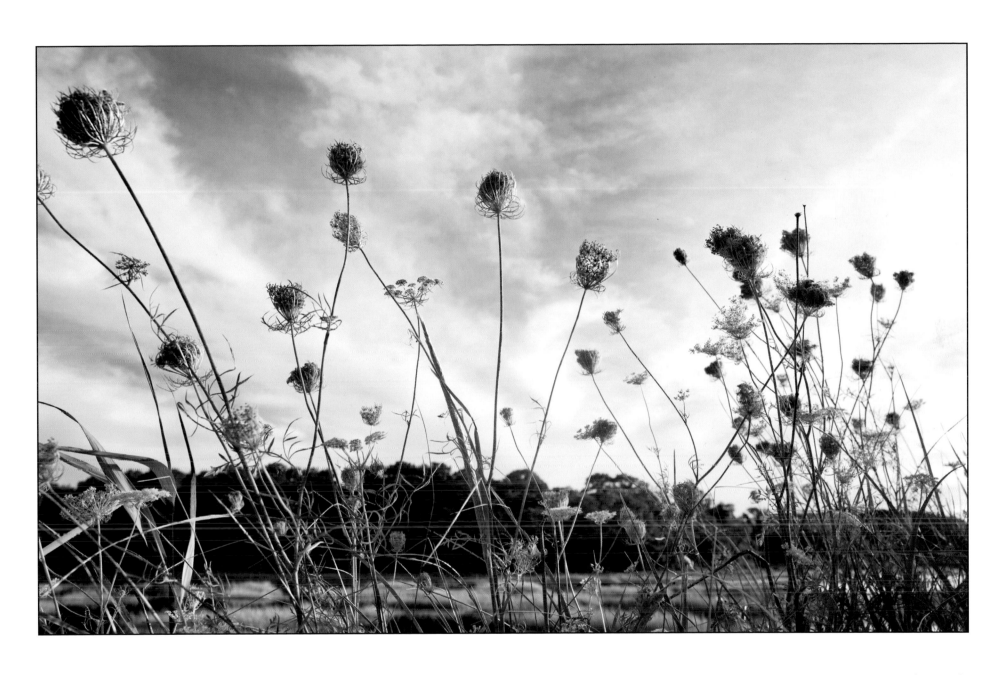

Marsh Weeds

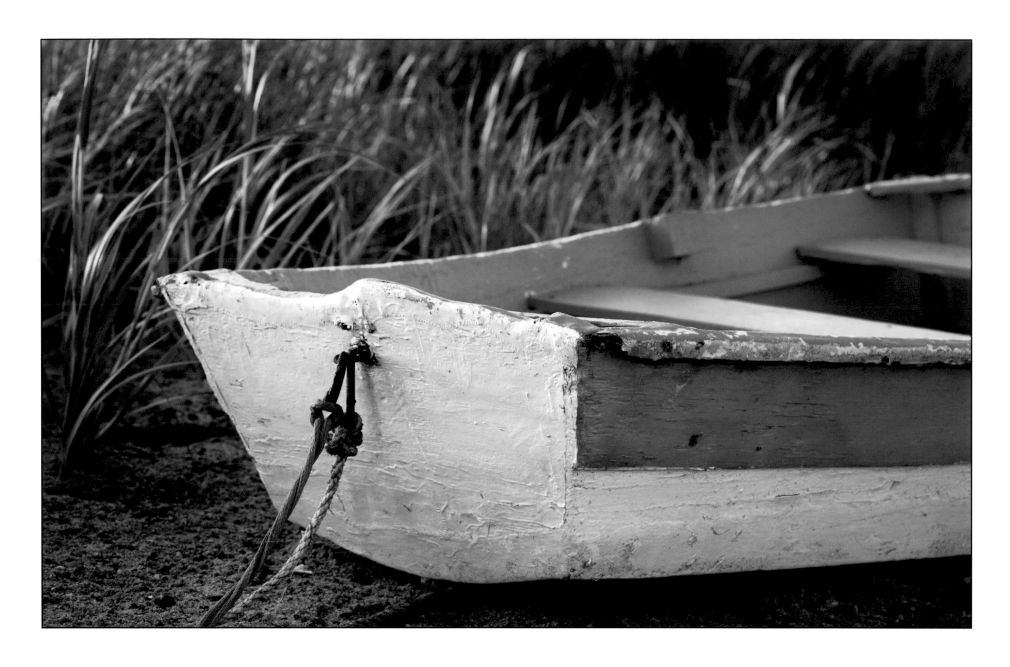

Blue Boat

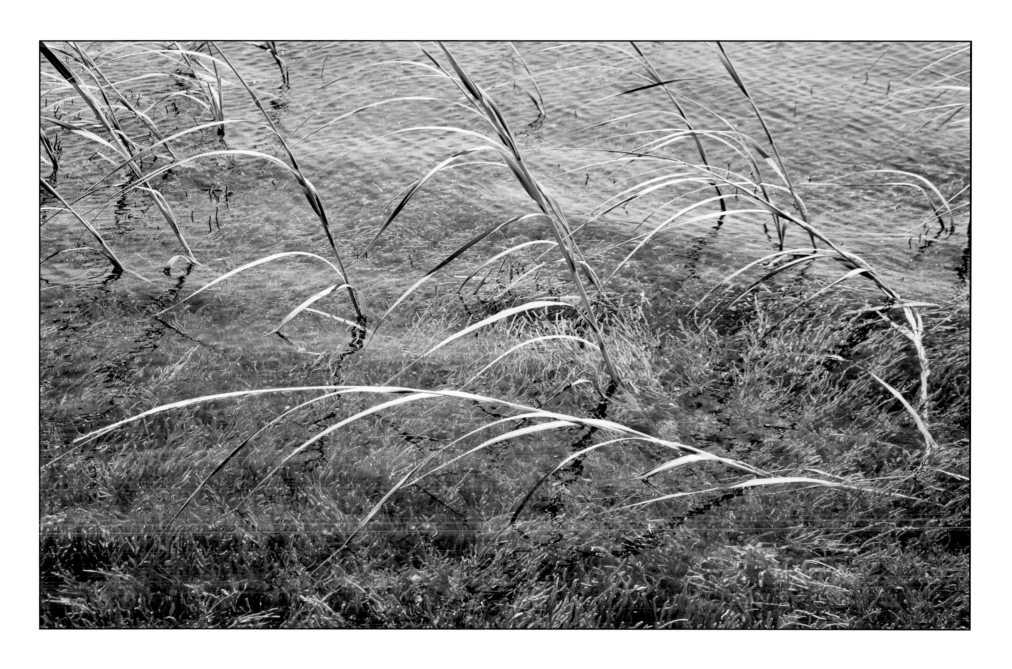

Spartina

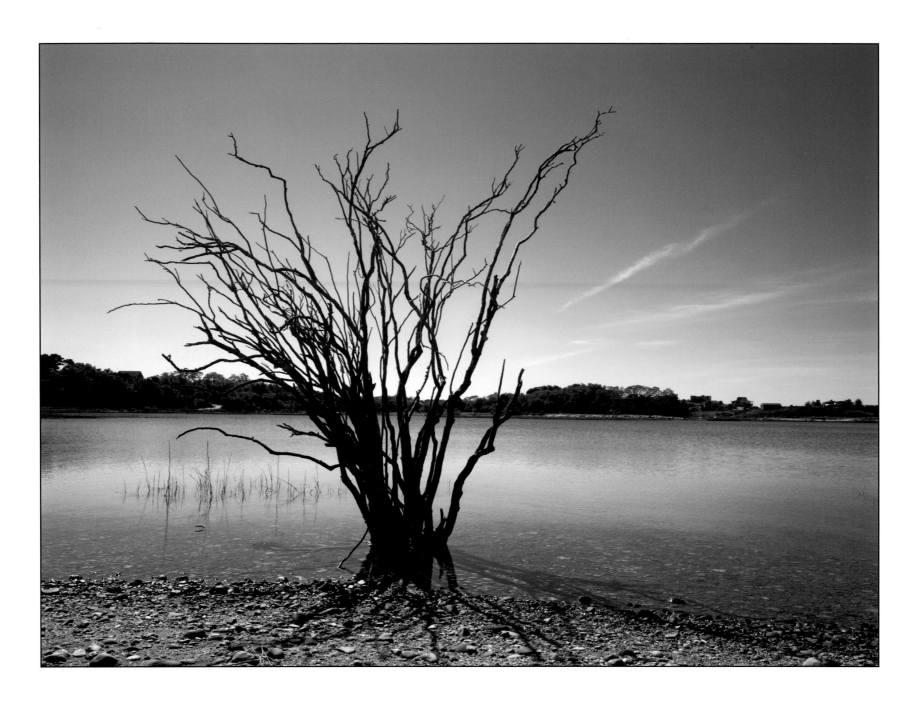

Dark Tree

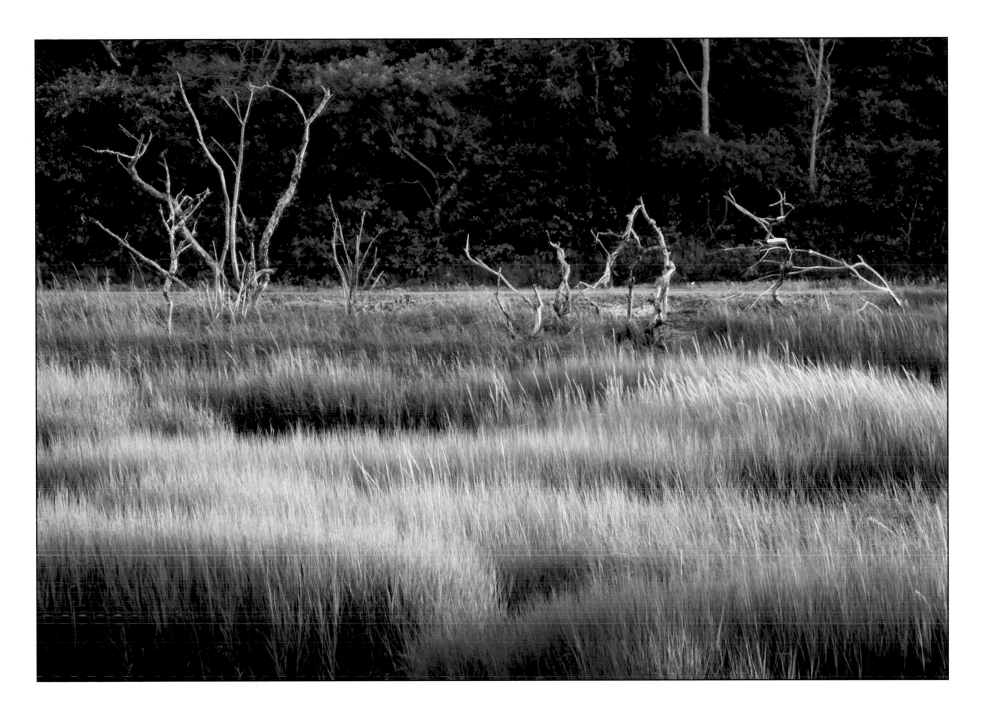

Marsh Trees

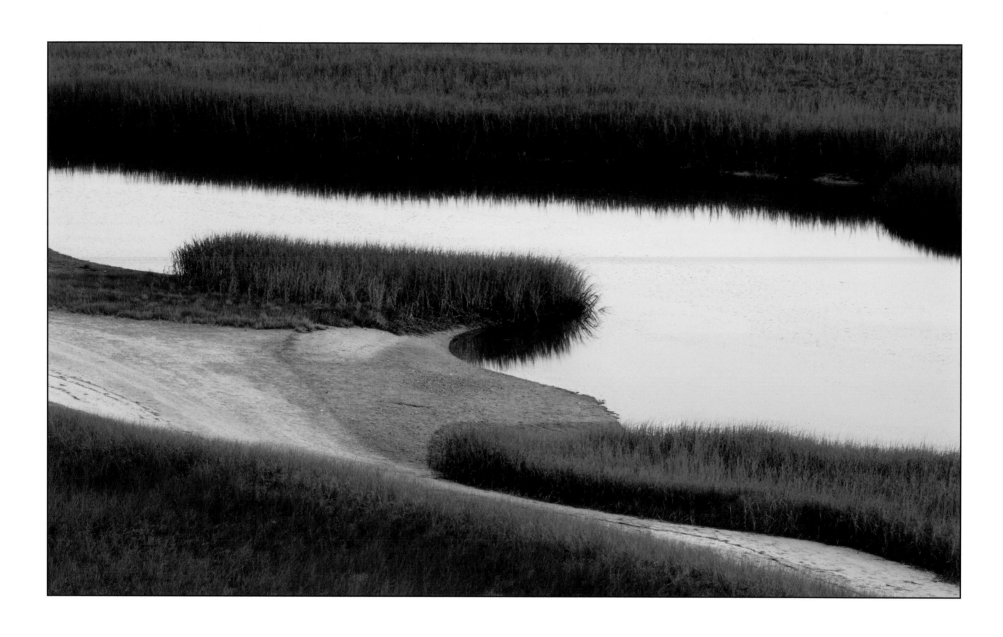

North Marsh

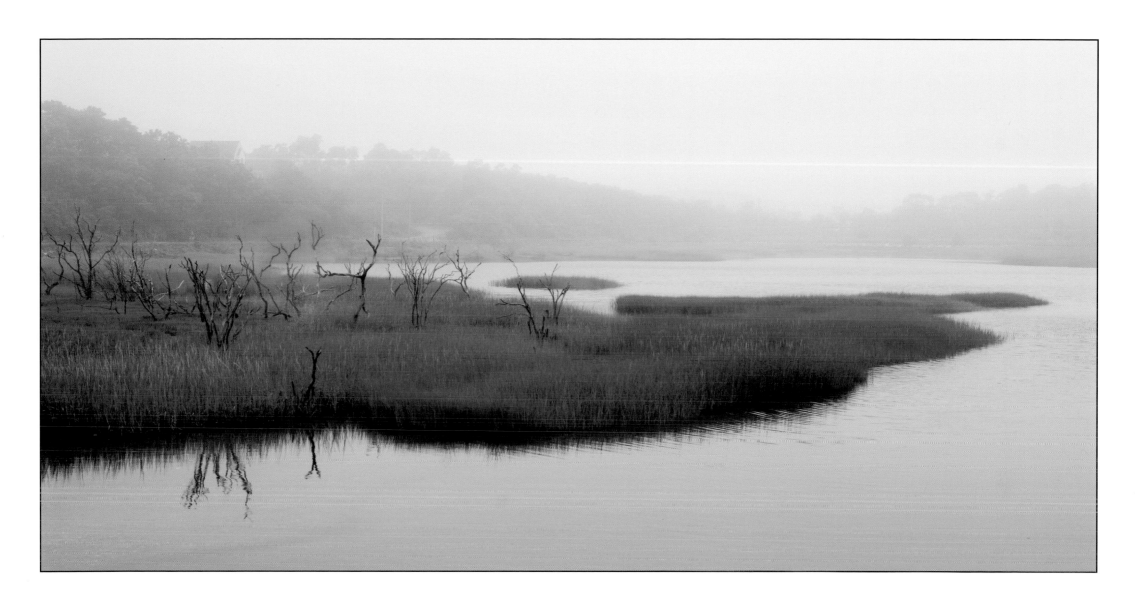

Marsh Mist

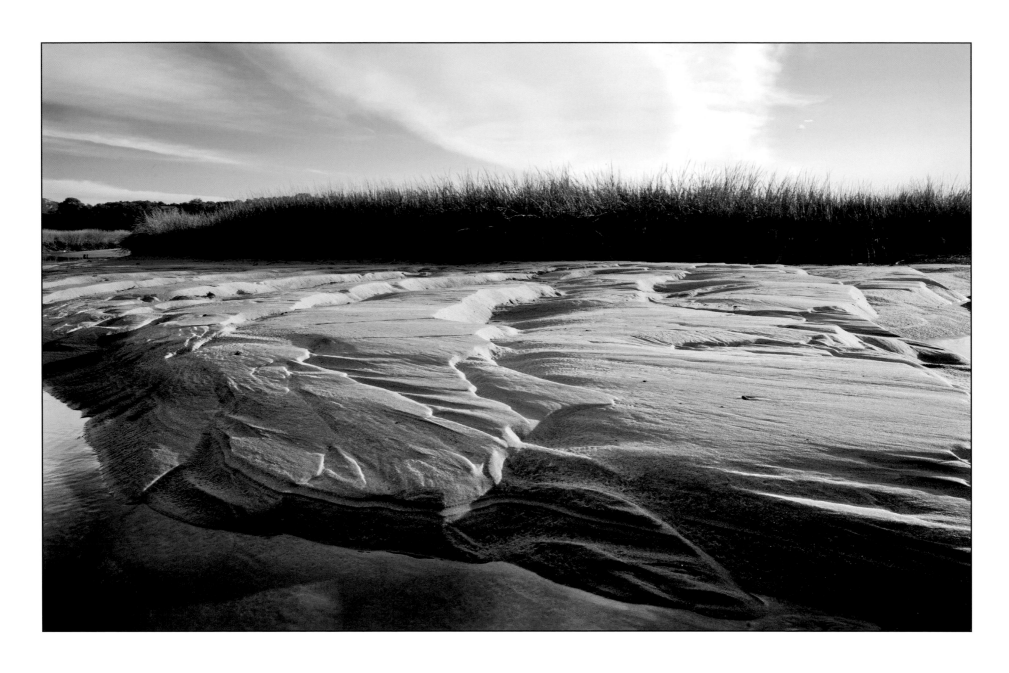

Low Tide, Snow's Landing

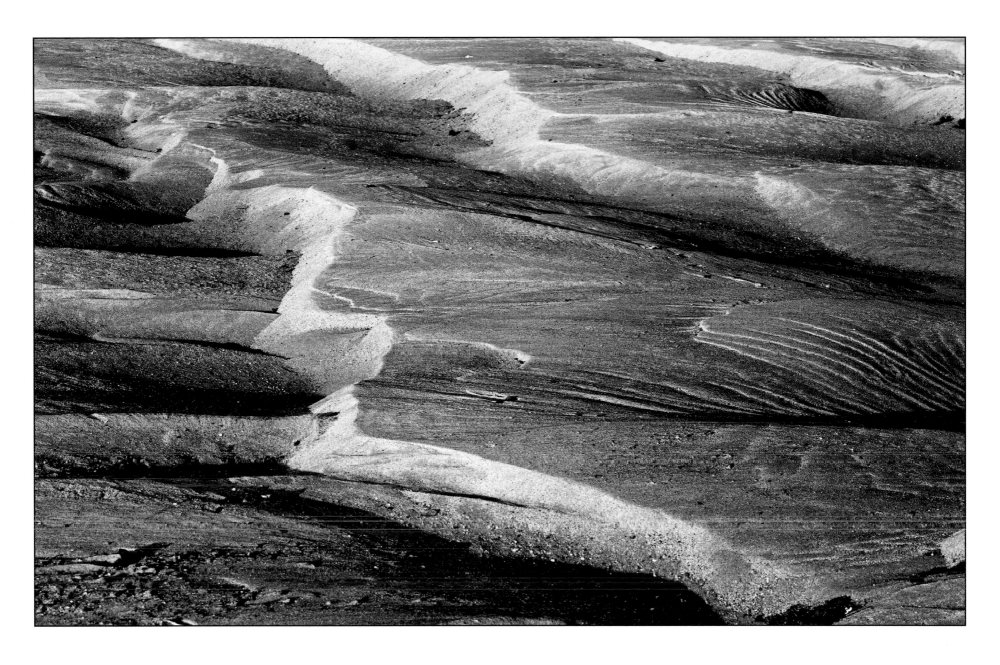

Sand Pattern III

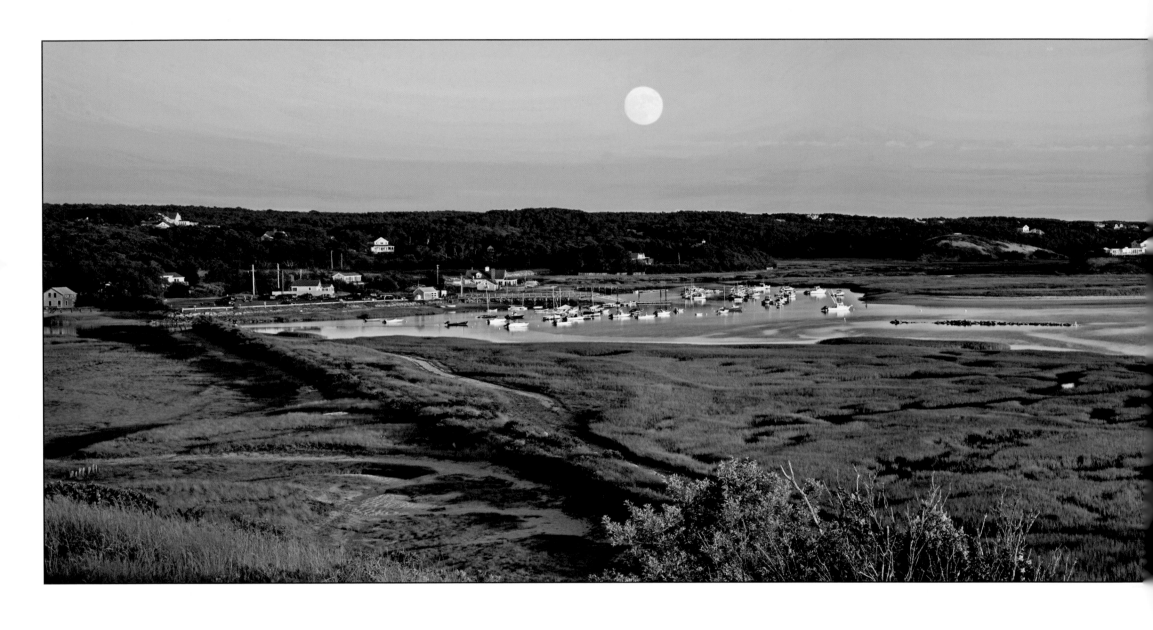

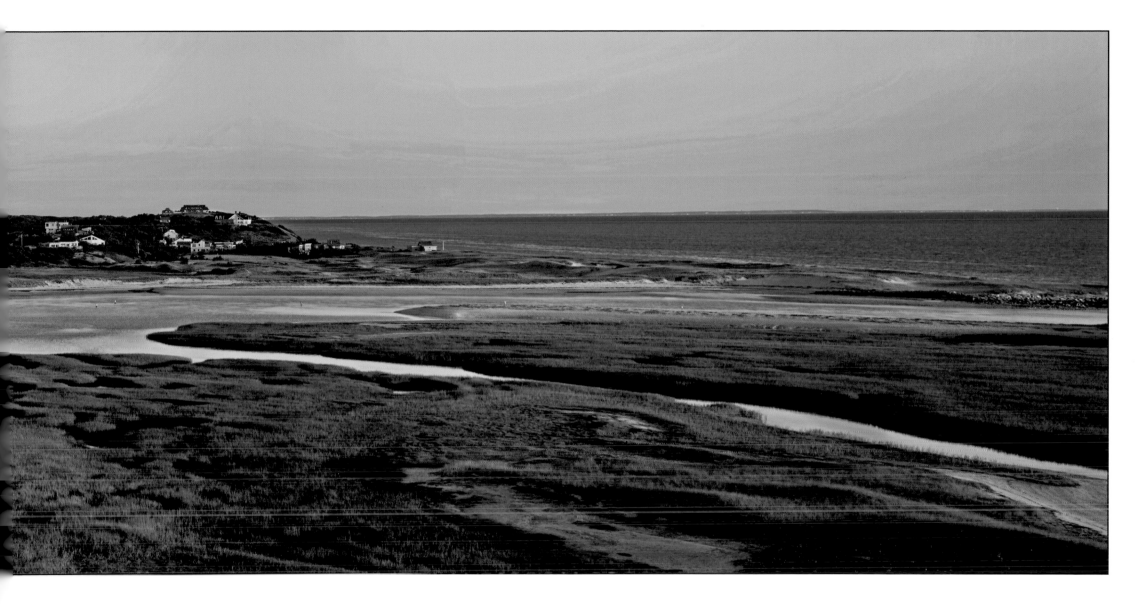

View from Tom's Hill

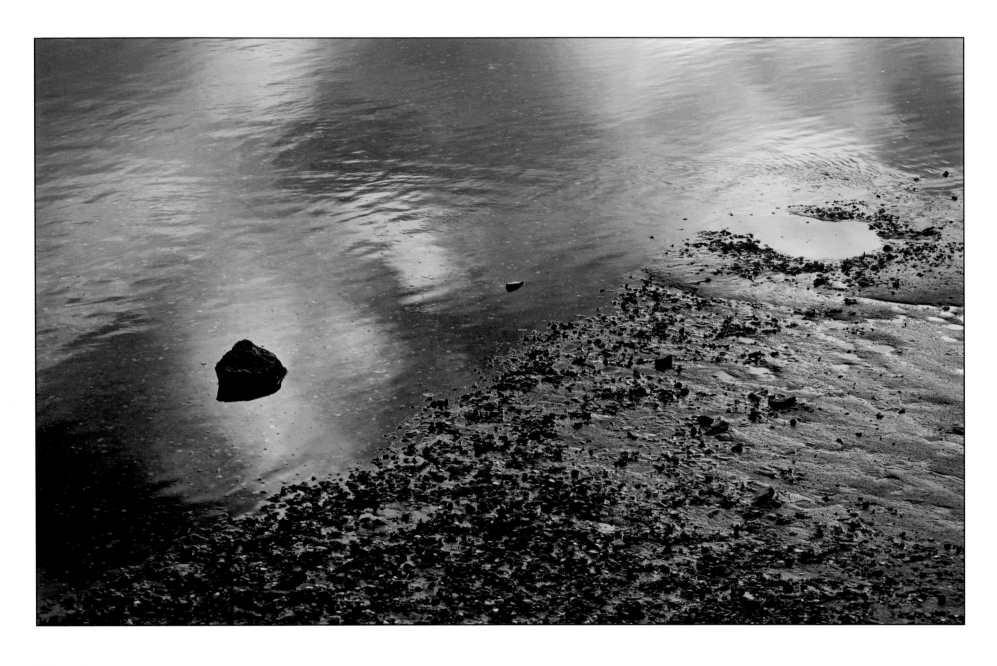

Marsh Stone

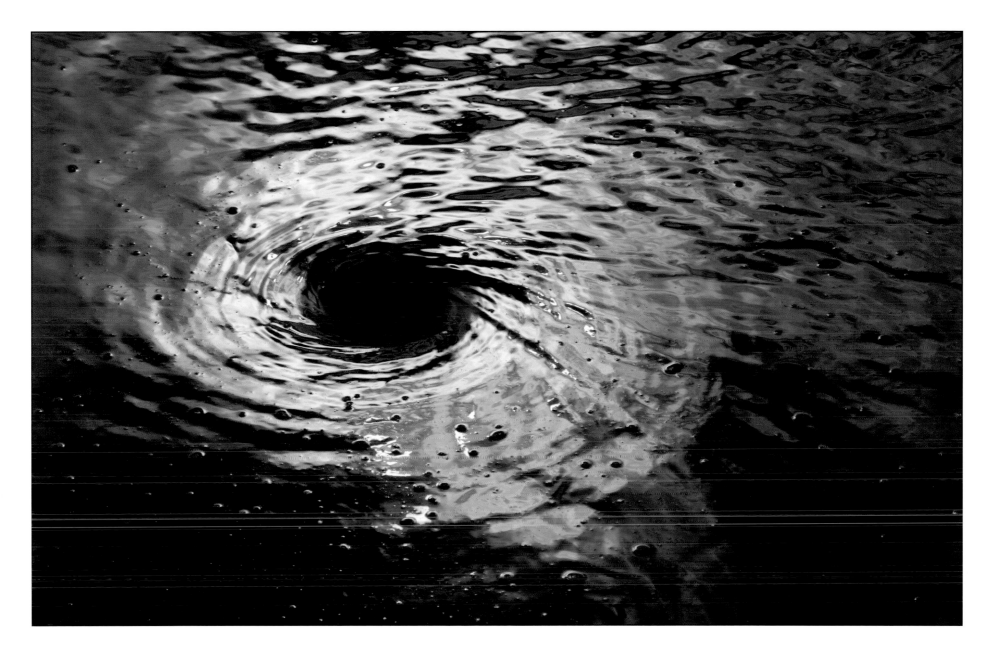

Whirlpool

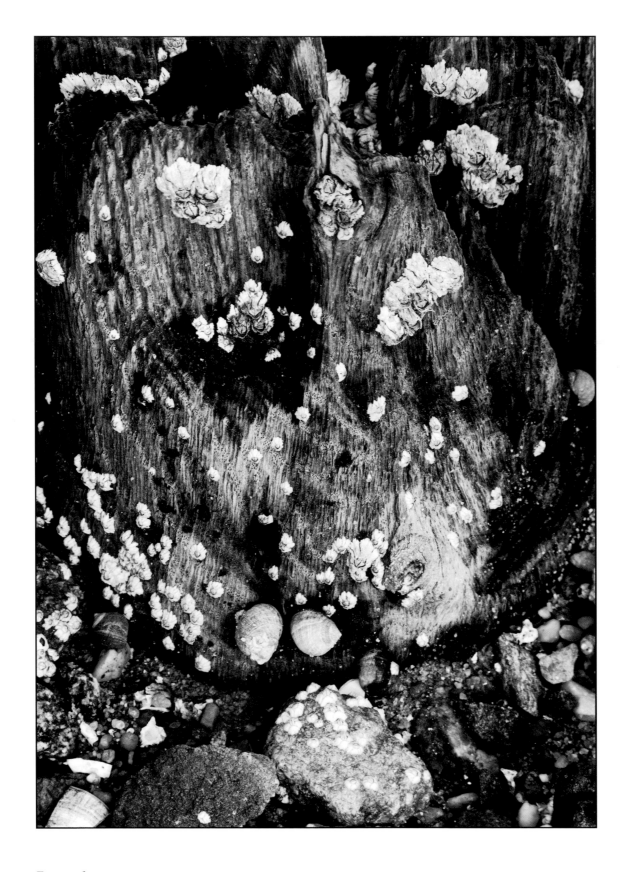

Barnacles

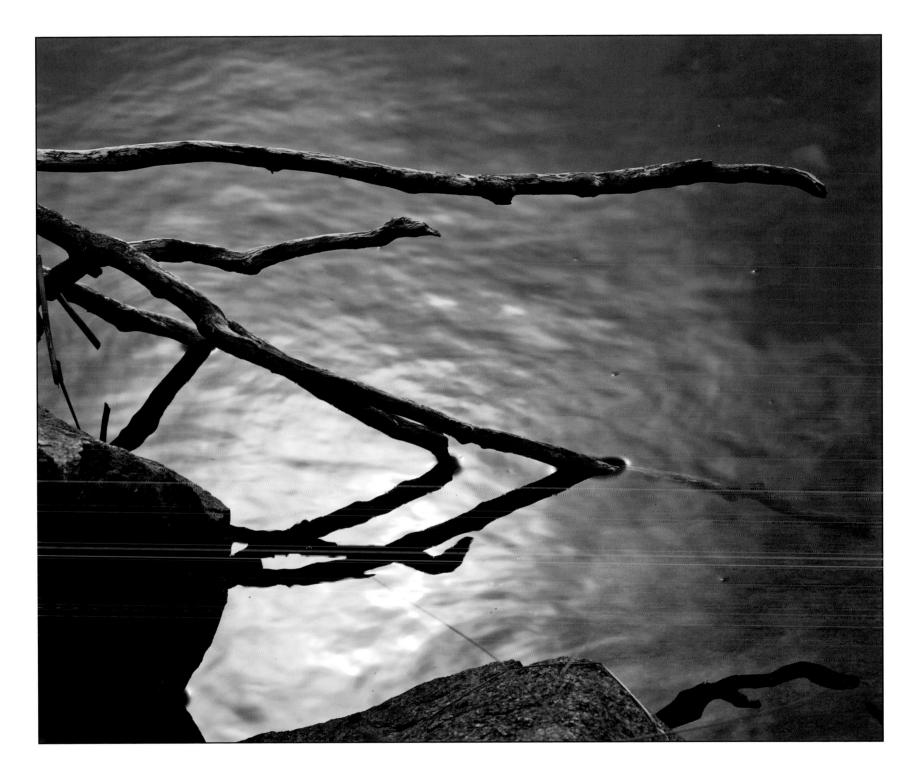

Marsh Light

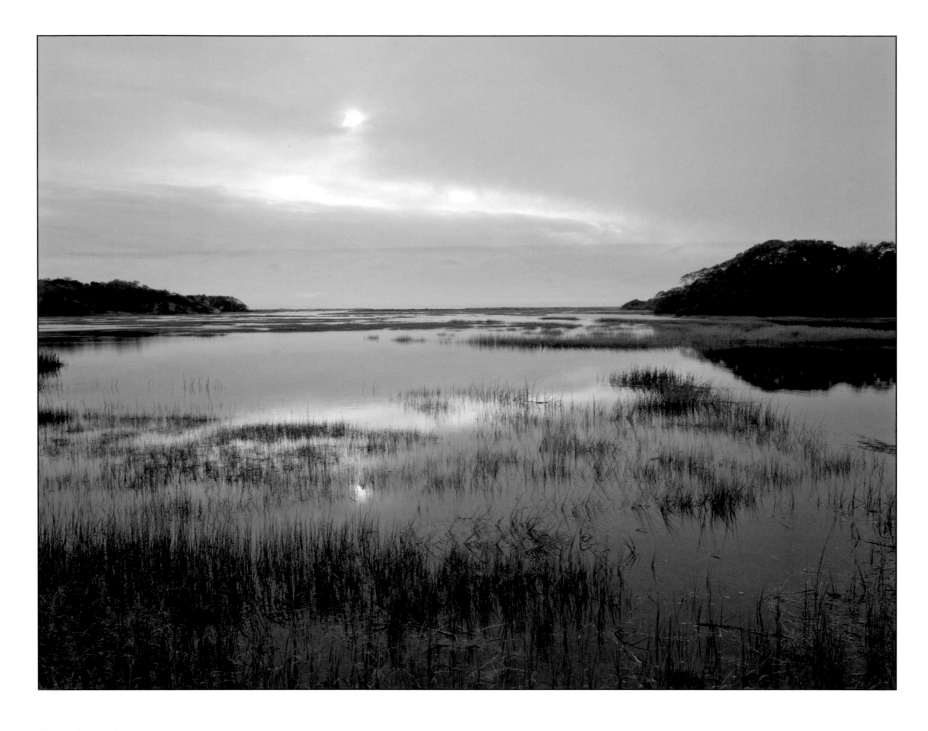

View from Snow's Landing

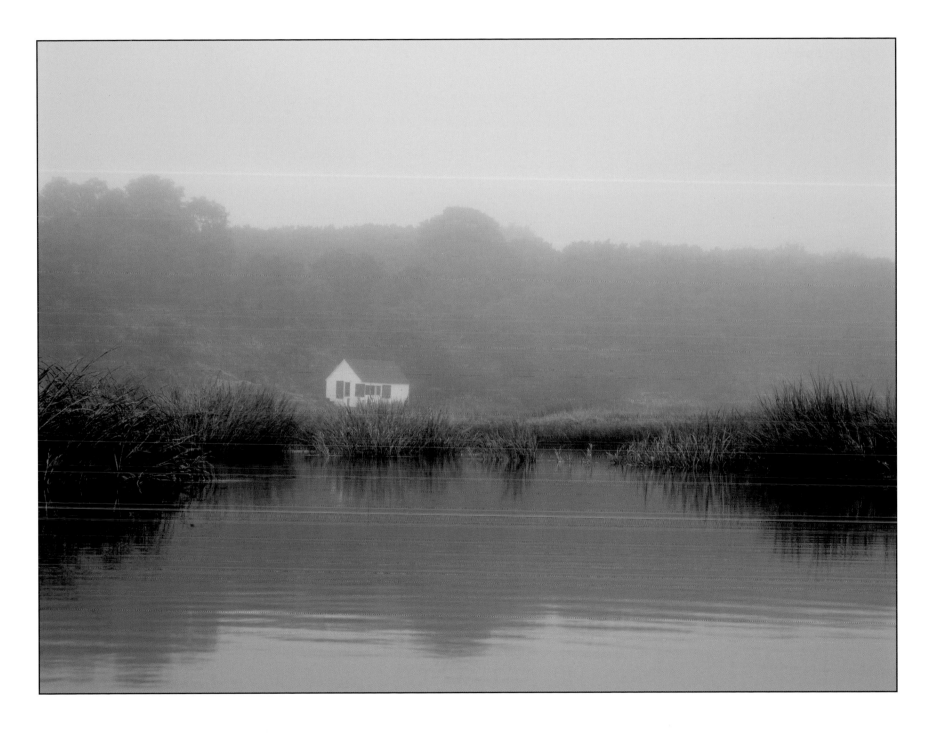

Boat House

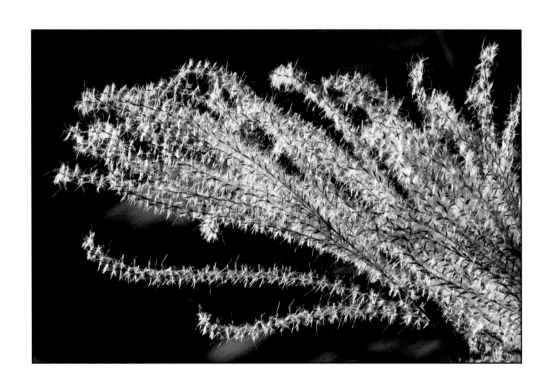

INLAND

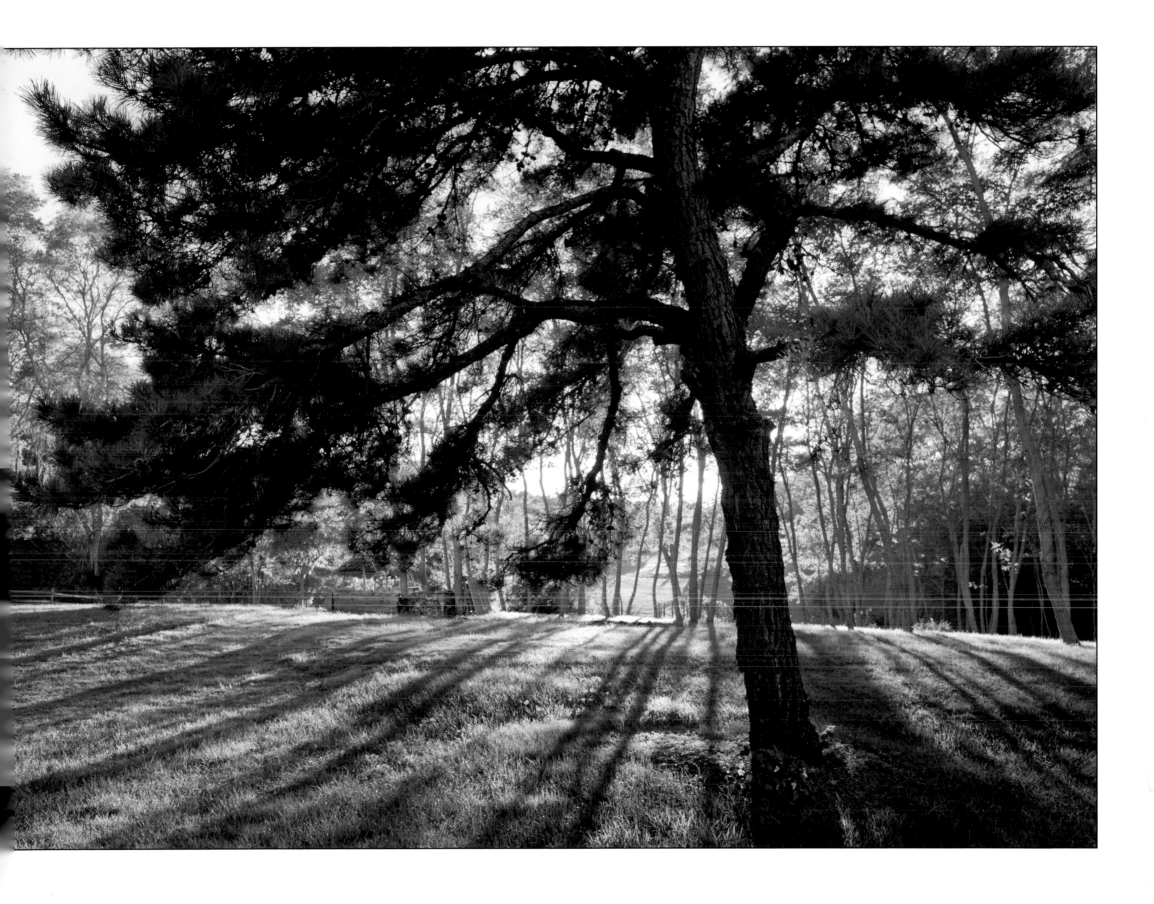

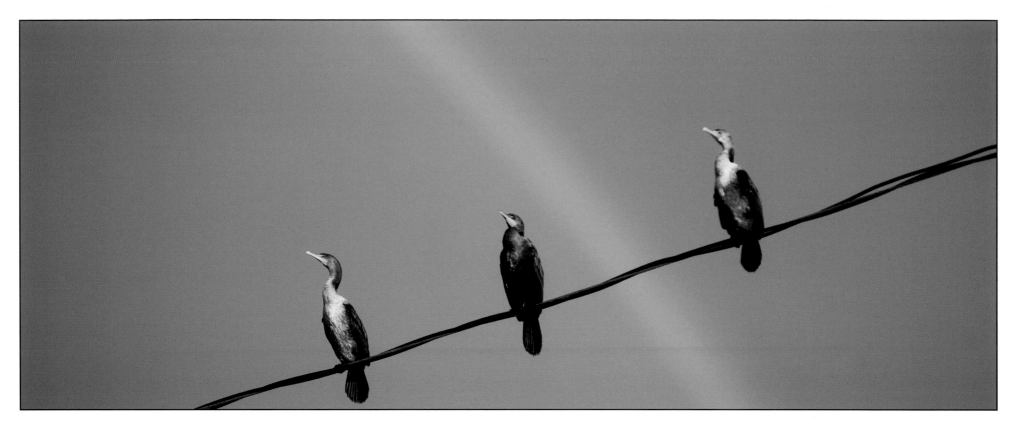

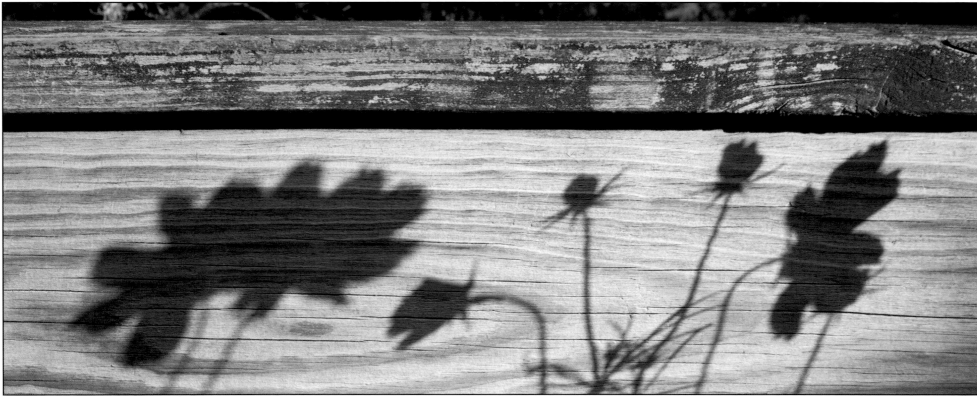

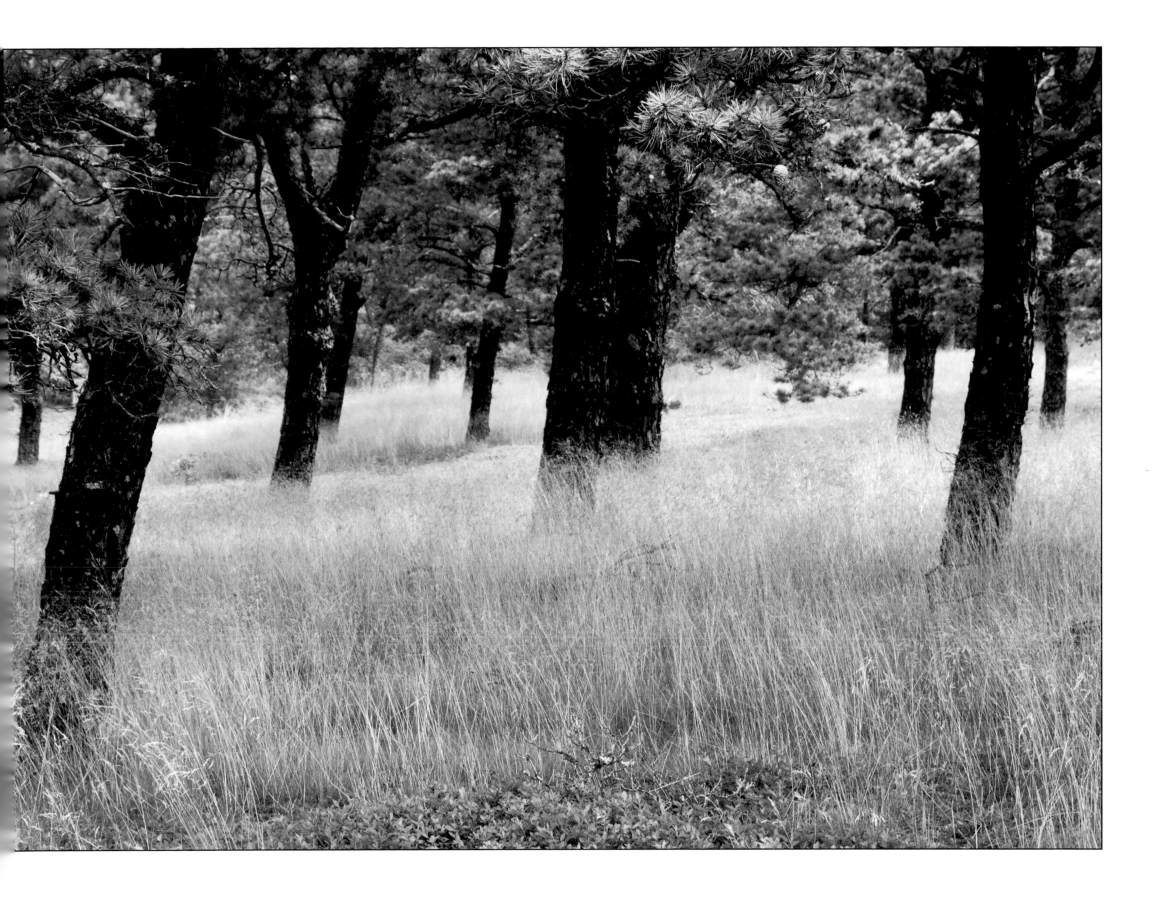

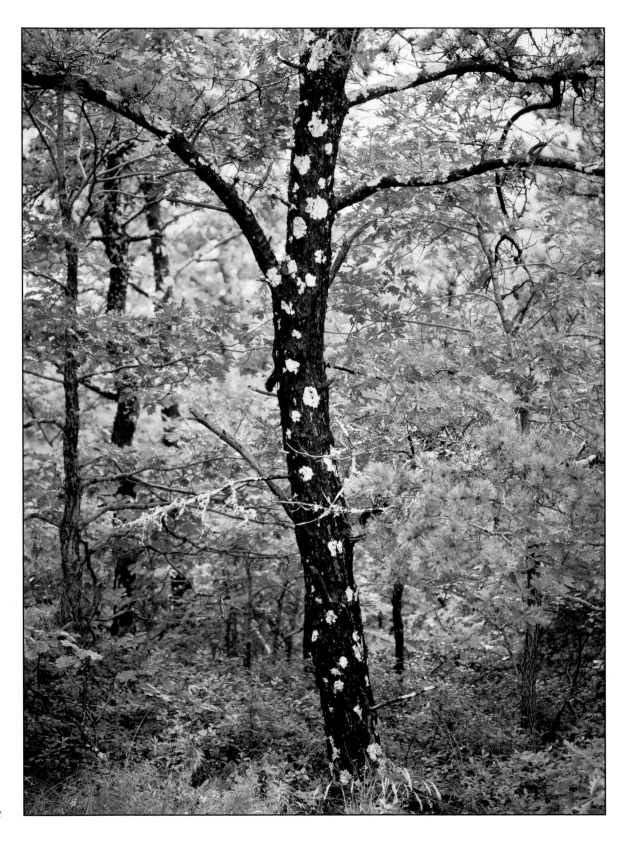

Spotted Pine

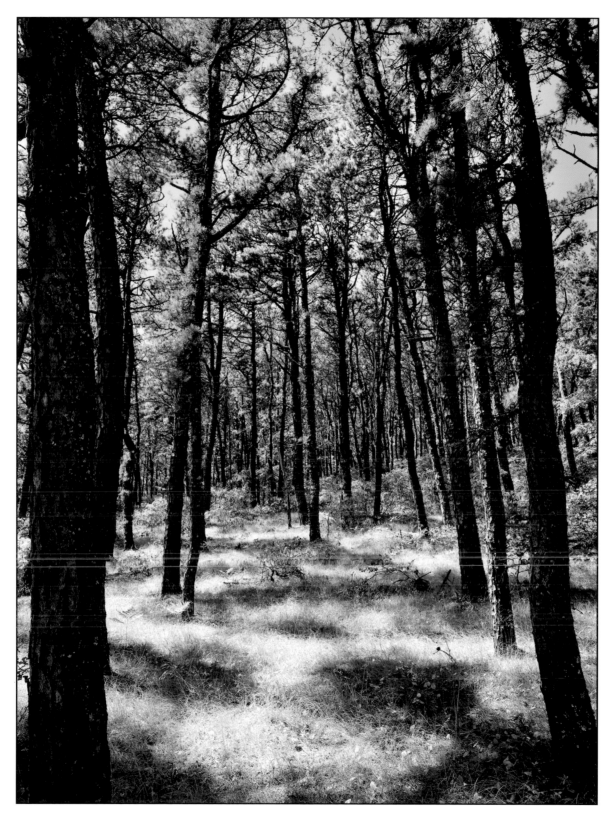

Collins Road

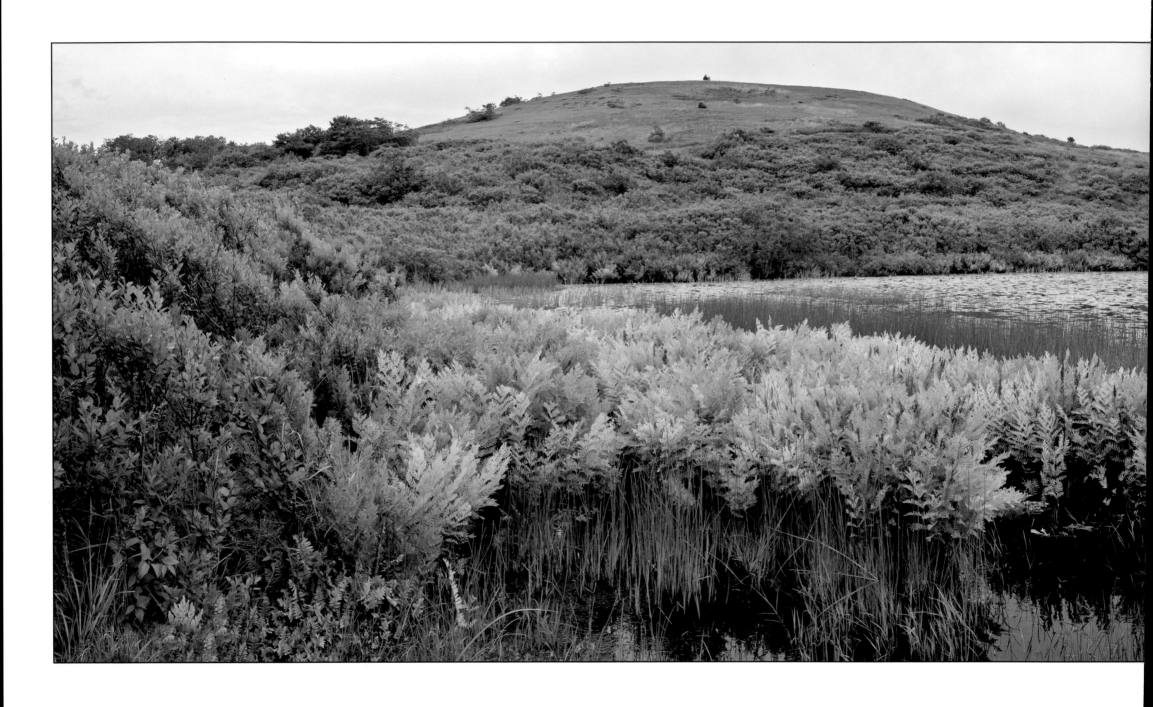

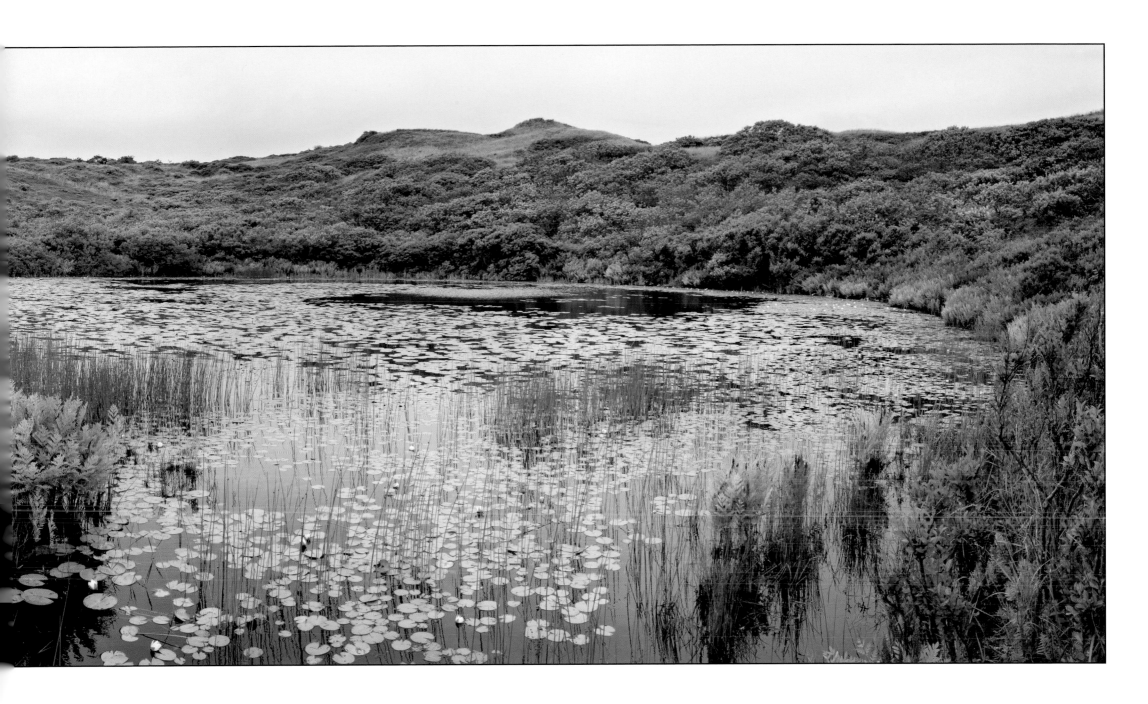

Frog Pond at Smalls Hill

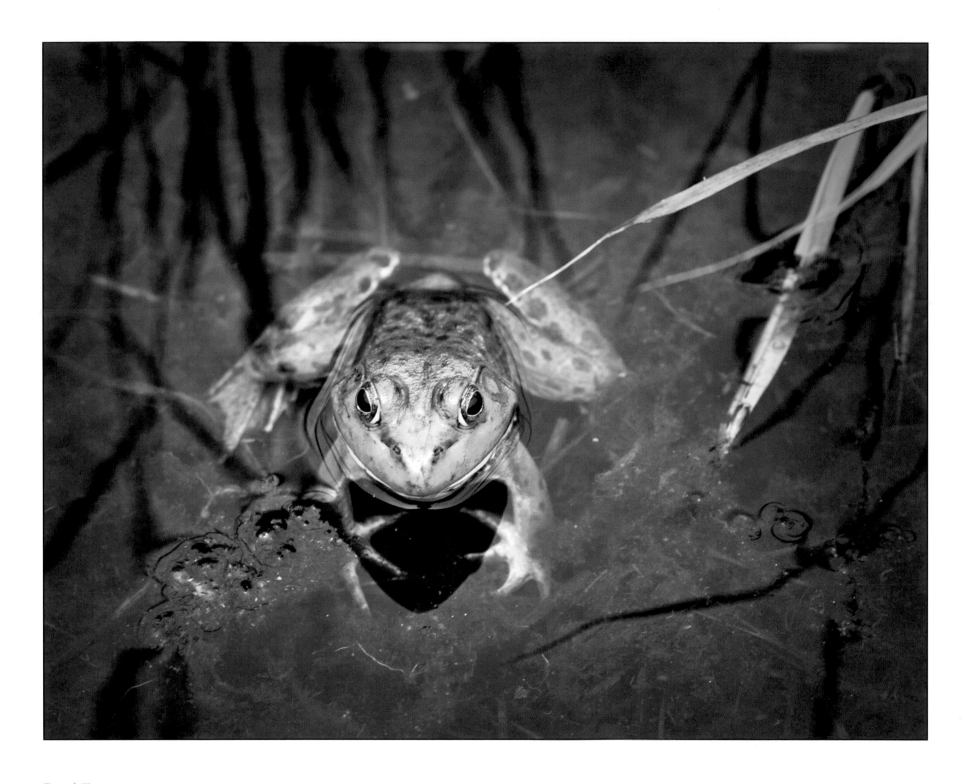

Pond Frog

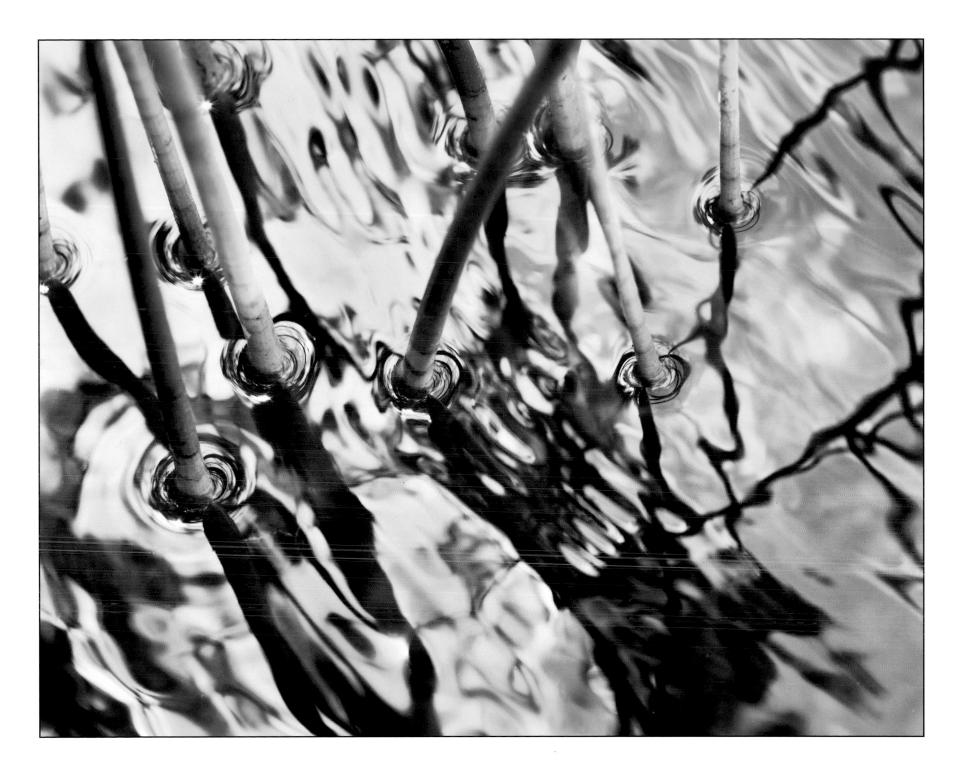

Pond Reeds

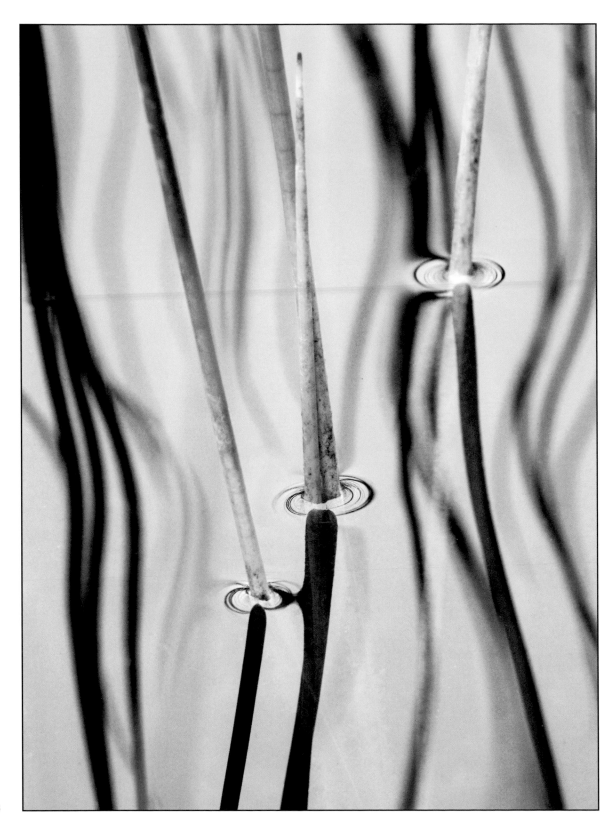

Pond Stems

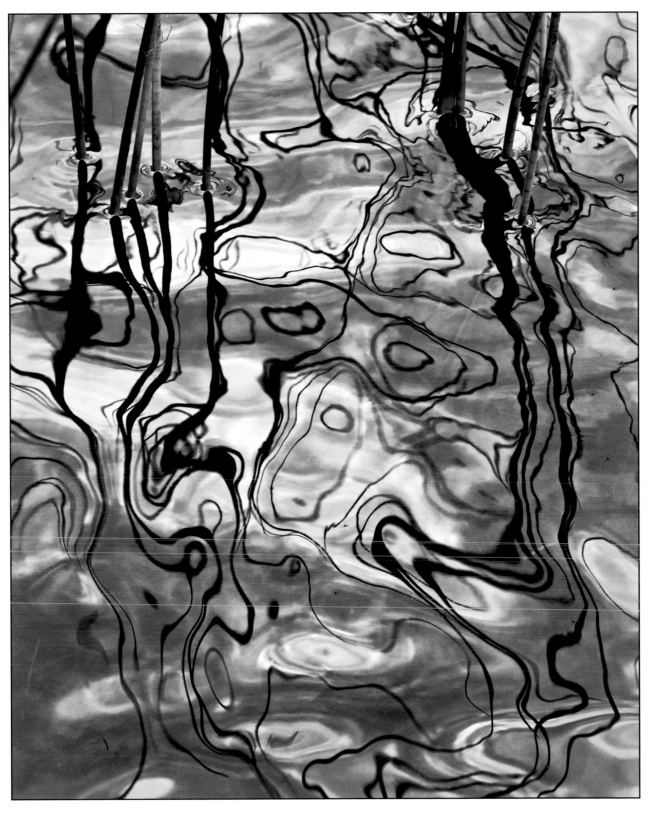

Pond Reflections

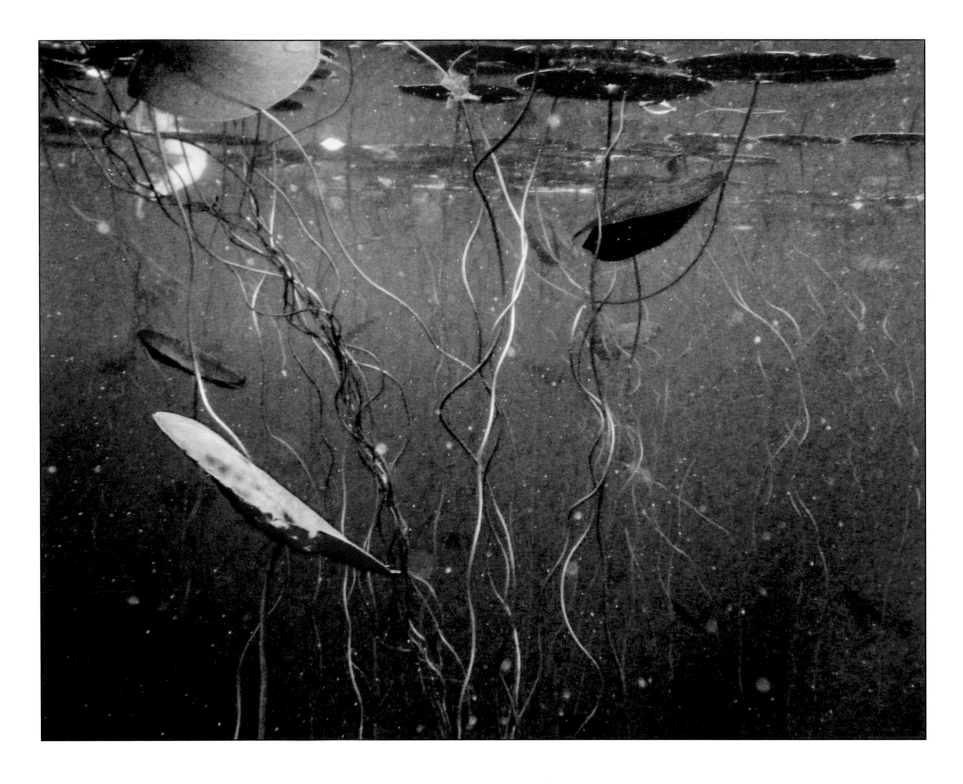

Pond Flora

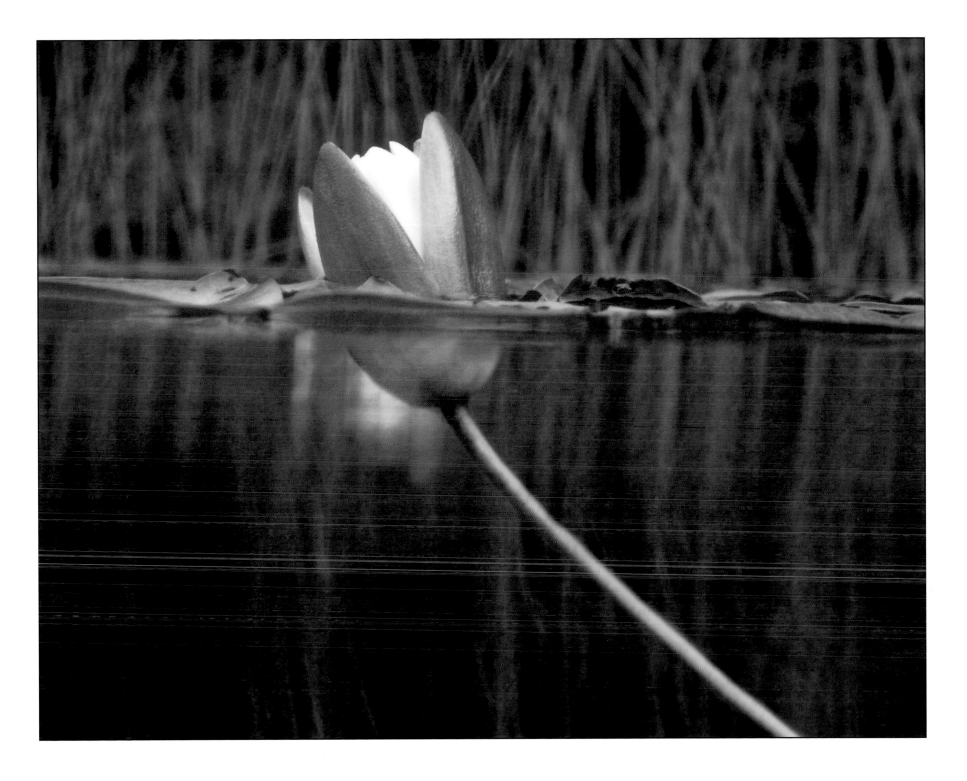

Lily

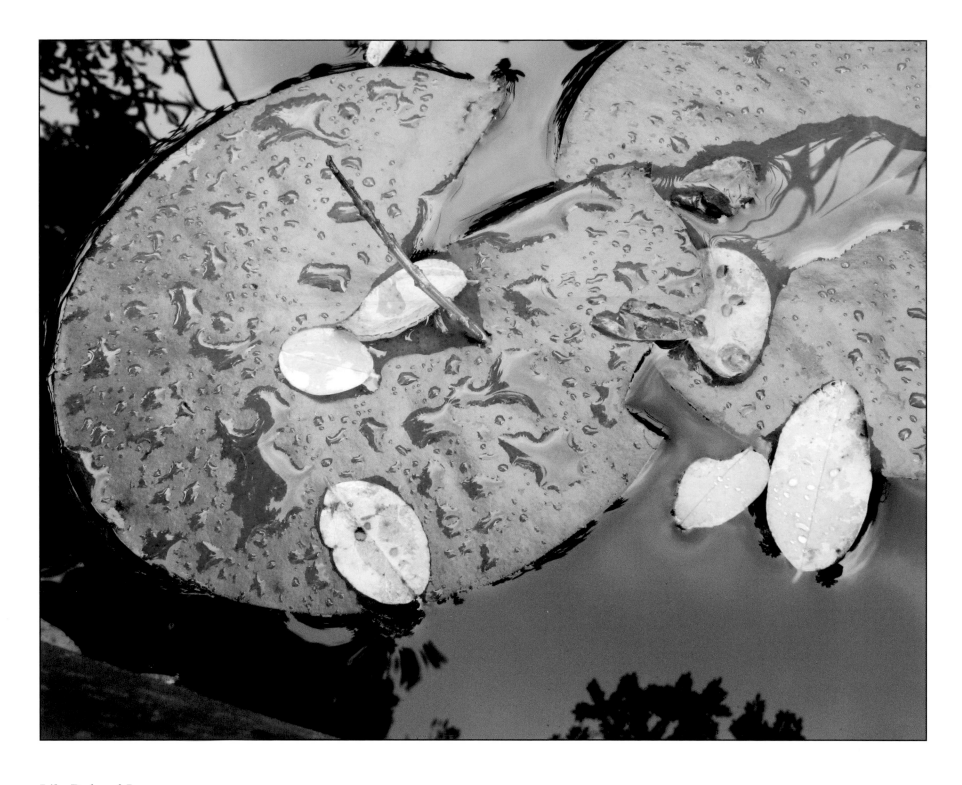

Lily Pad and Leaves

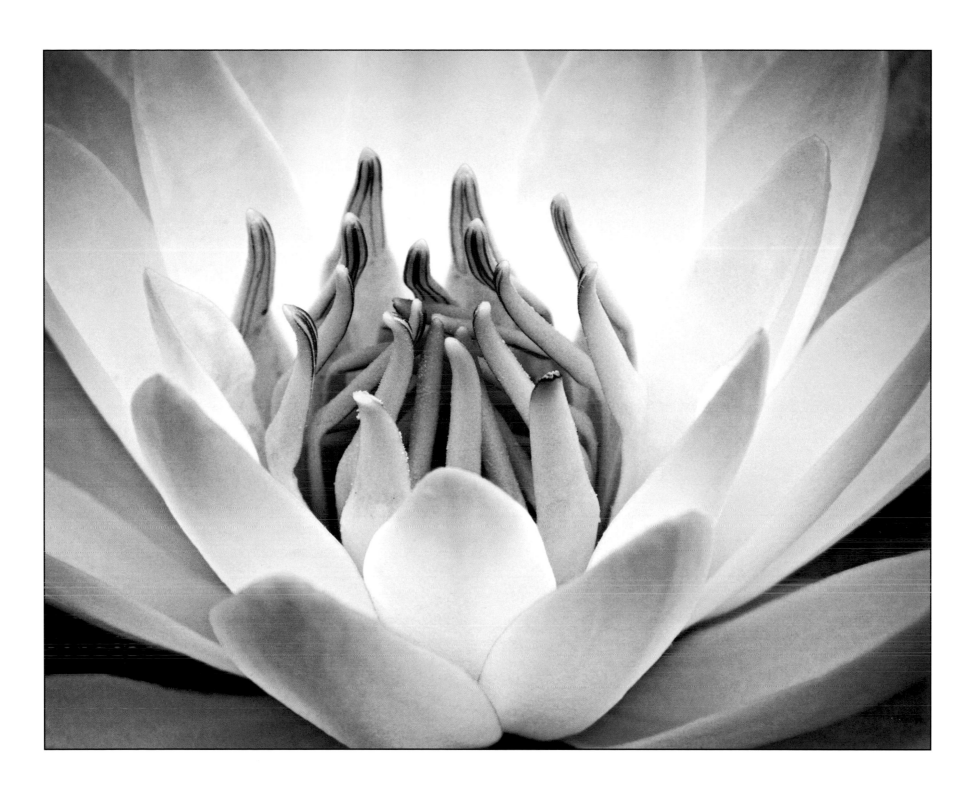

Freshwater Lily

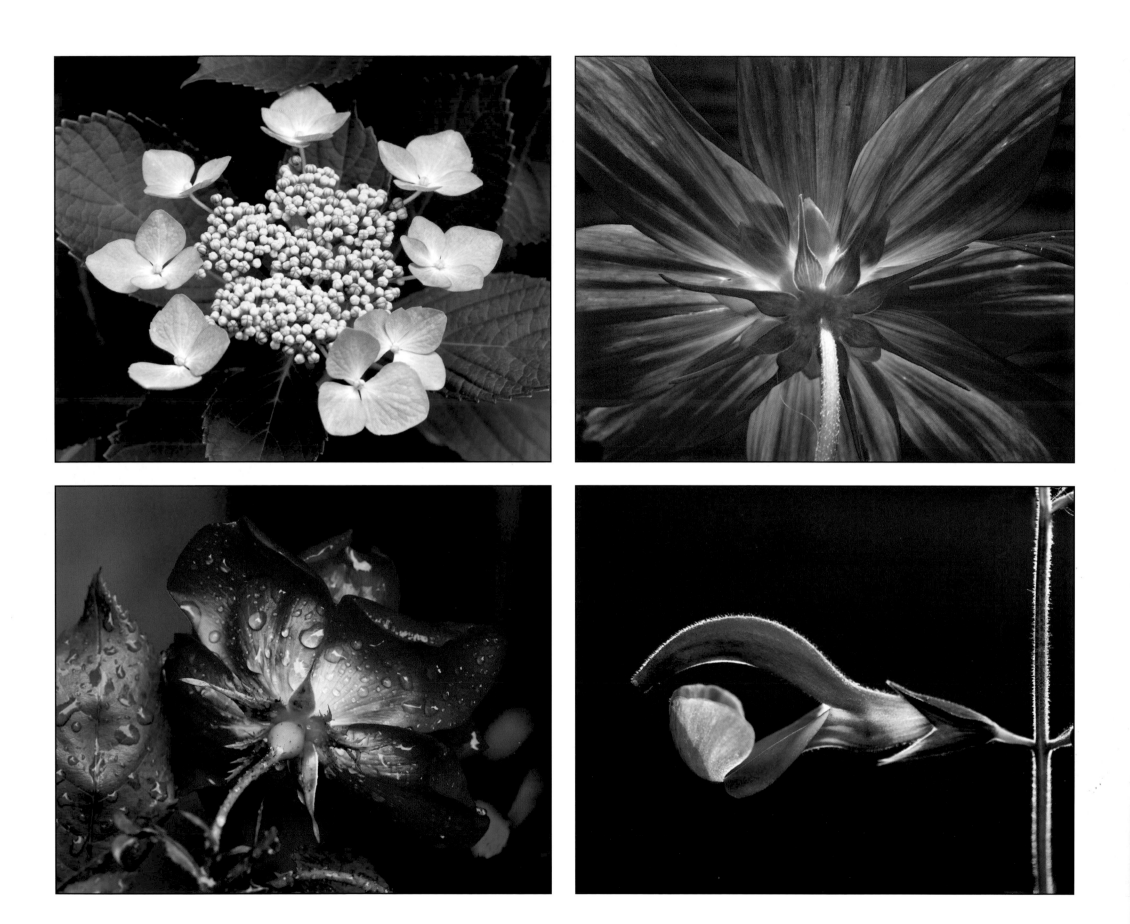

Truro Flowers

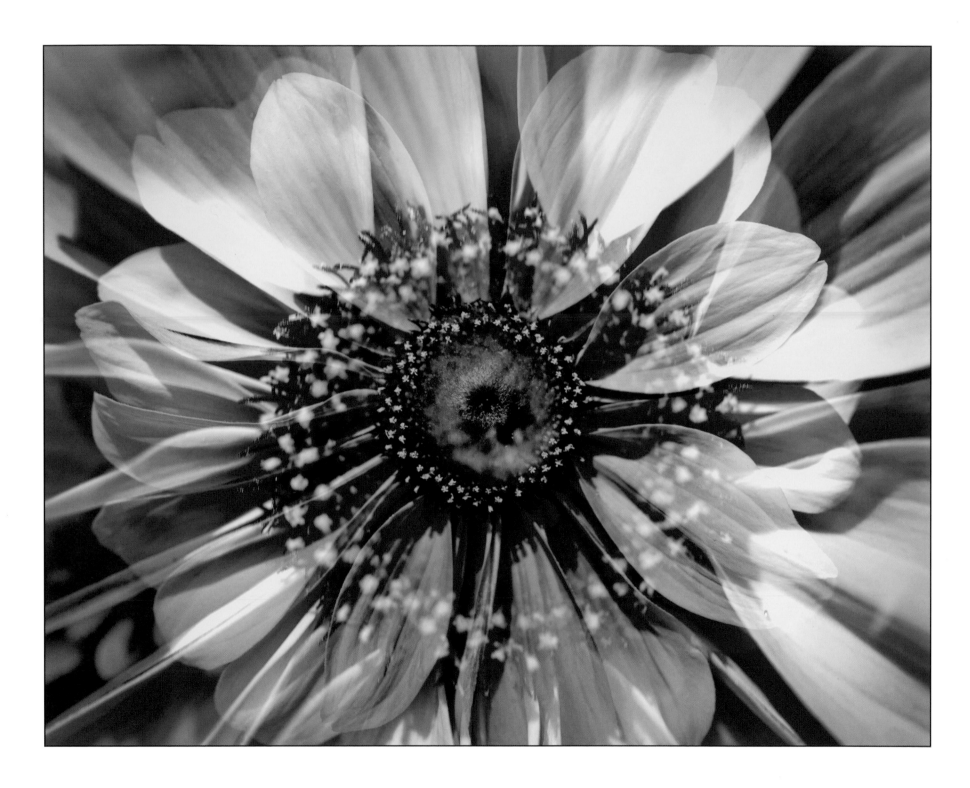

Double Flower

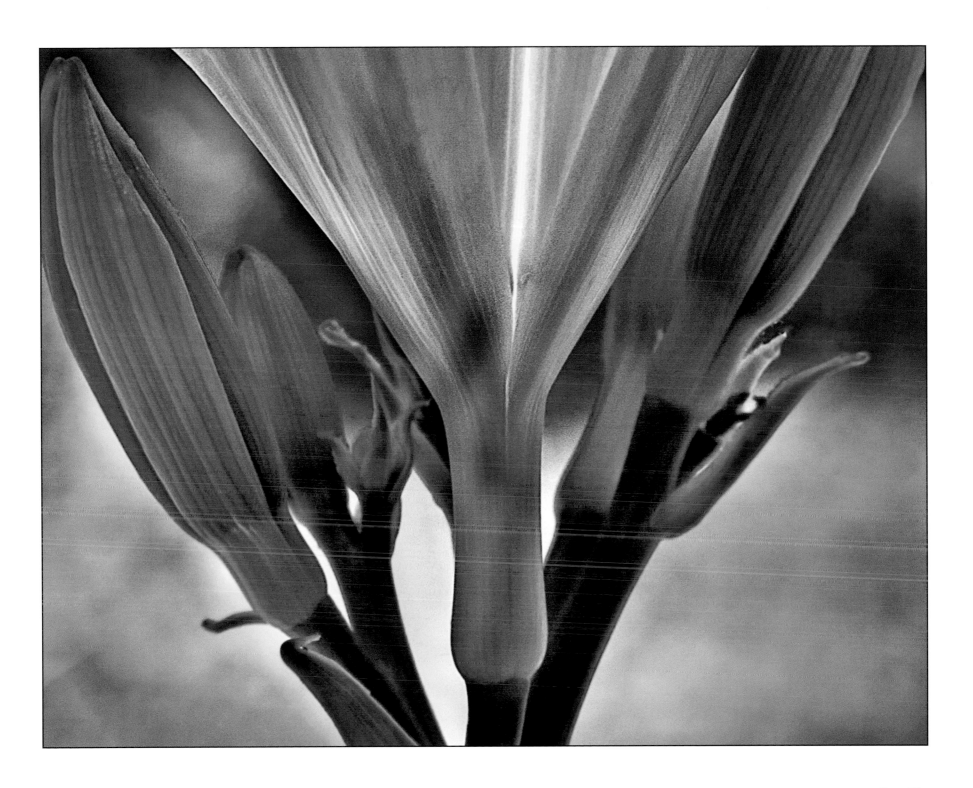

Daylily

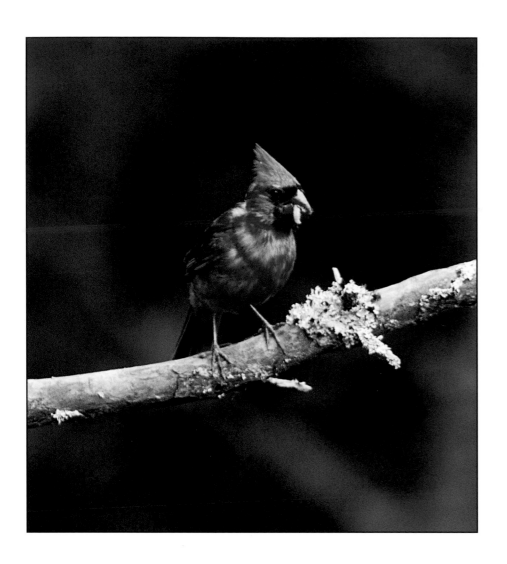
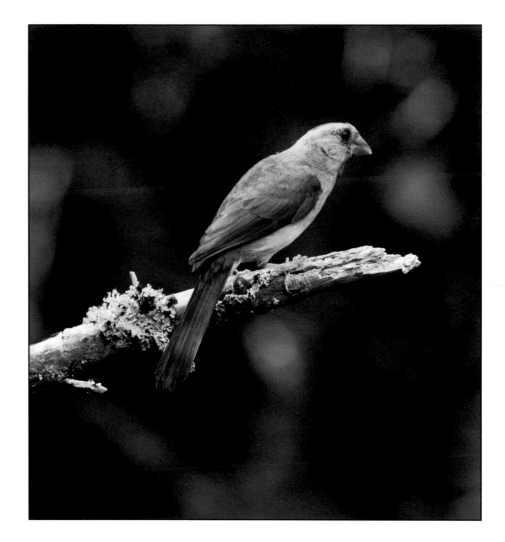

Feeding Their Babies

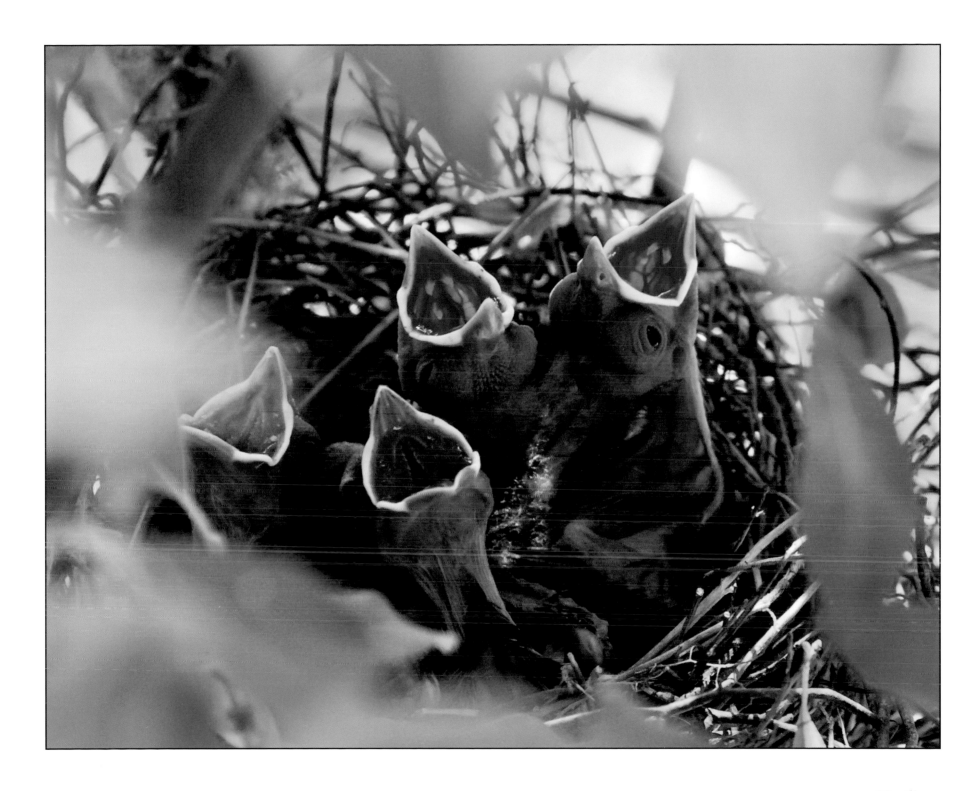

Nestlings

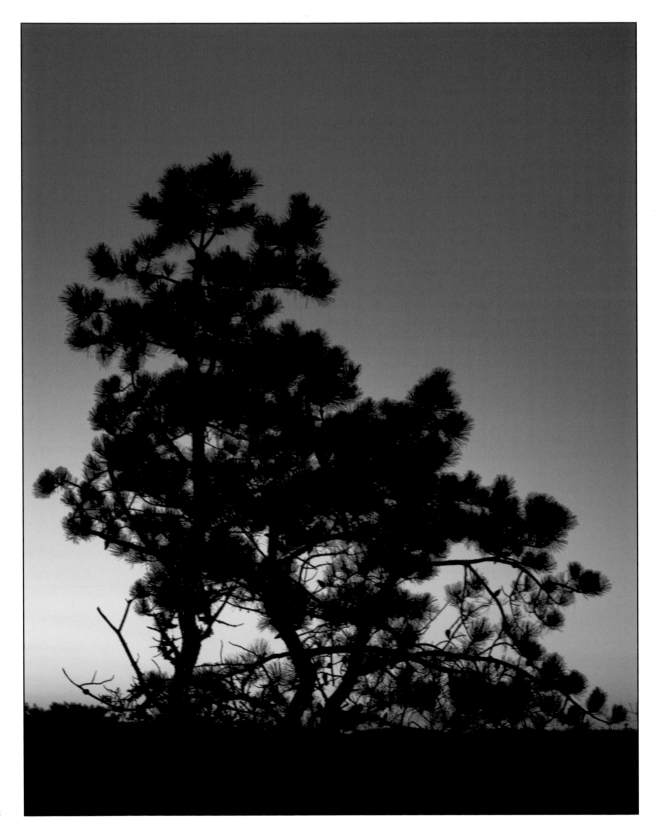

Evening Pines

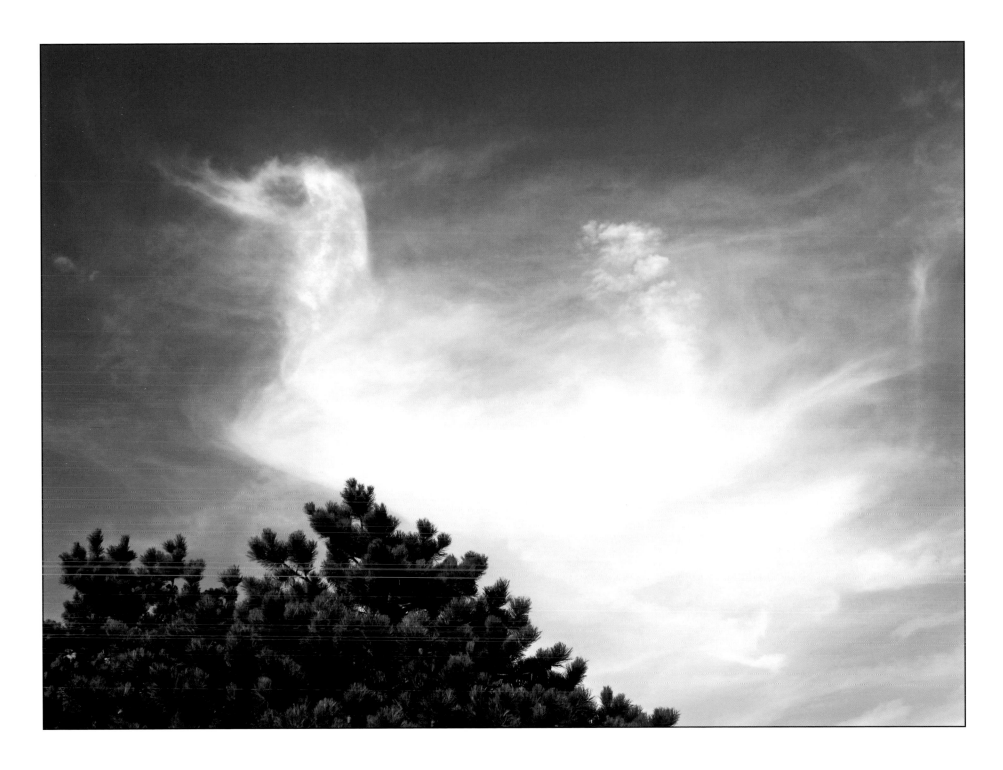

Swan Cloud

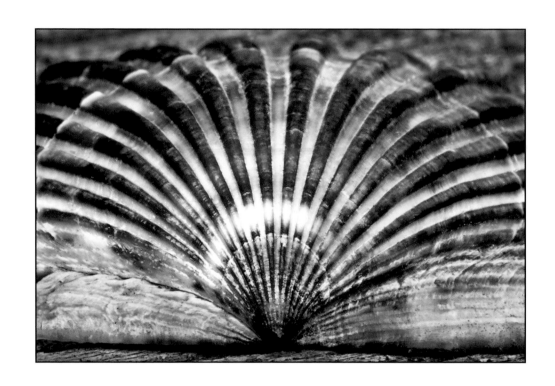

PAMET HARBOR

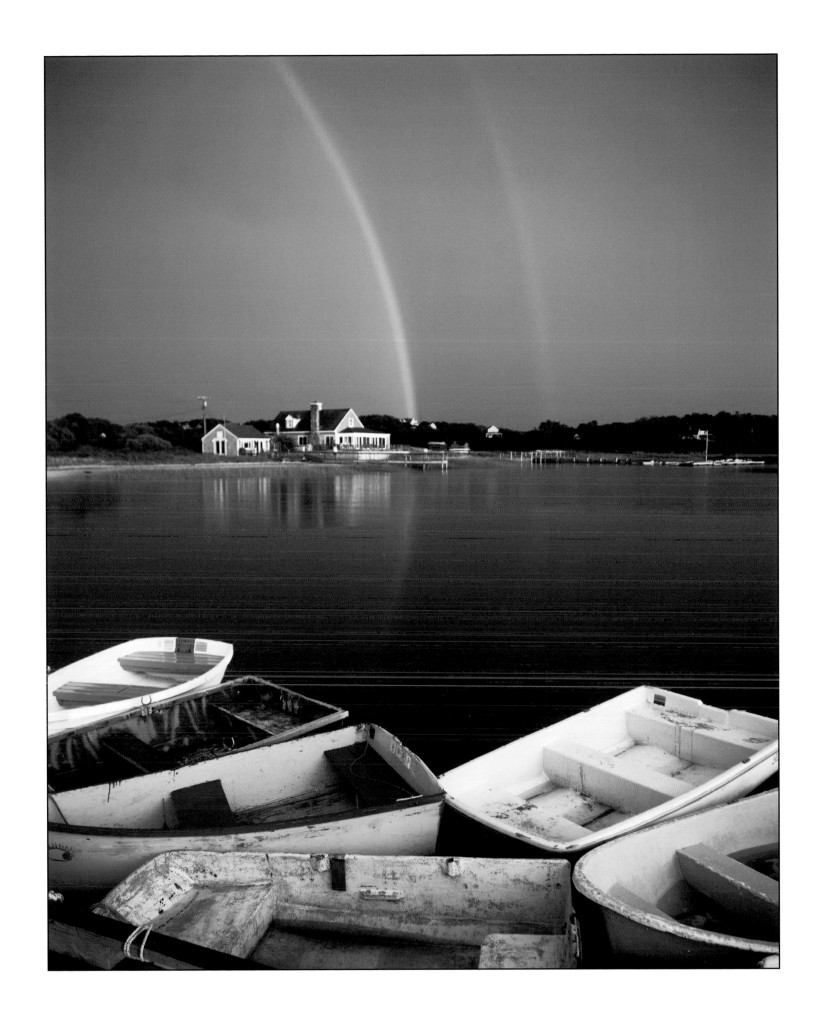

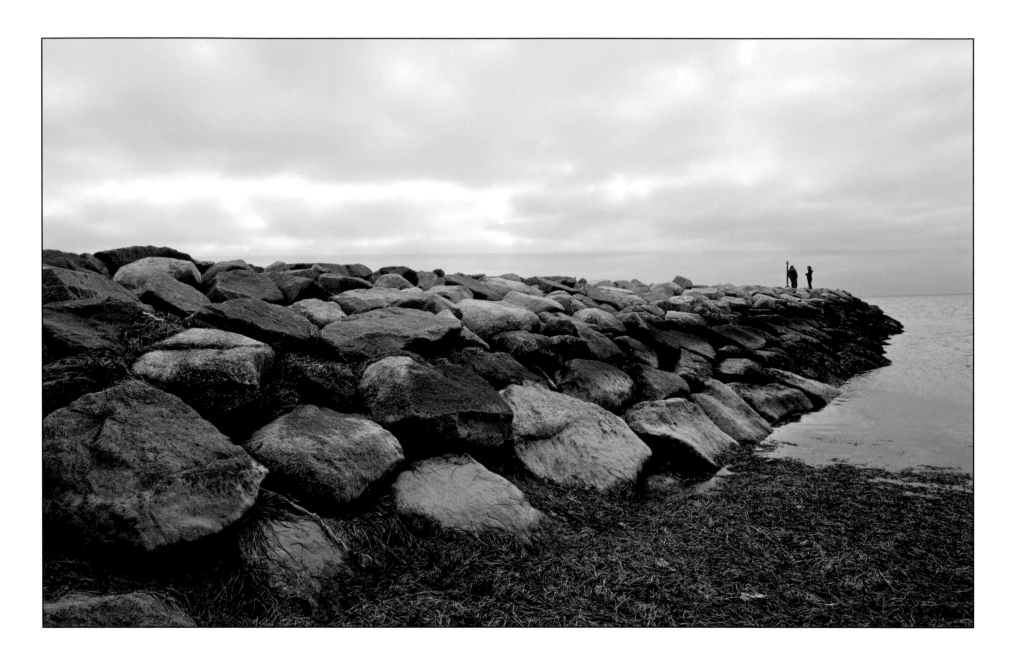

Breakwater

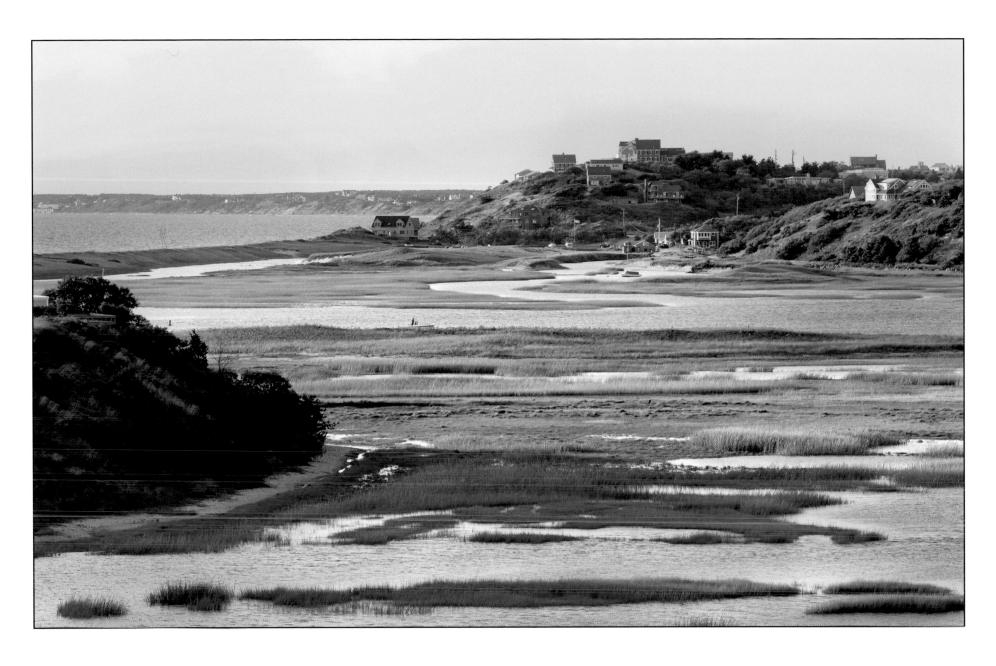

View from Poor's Hill

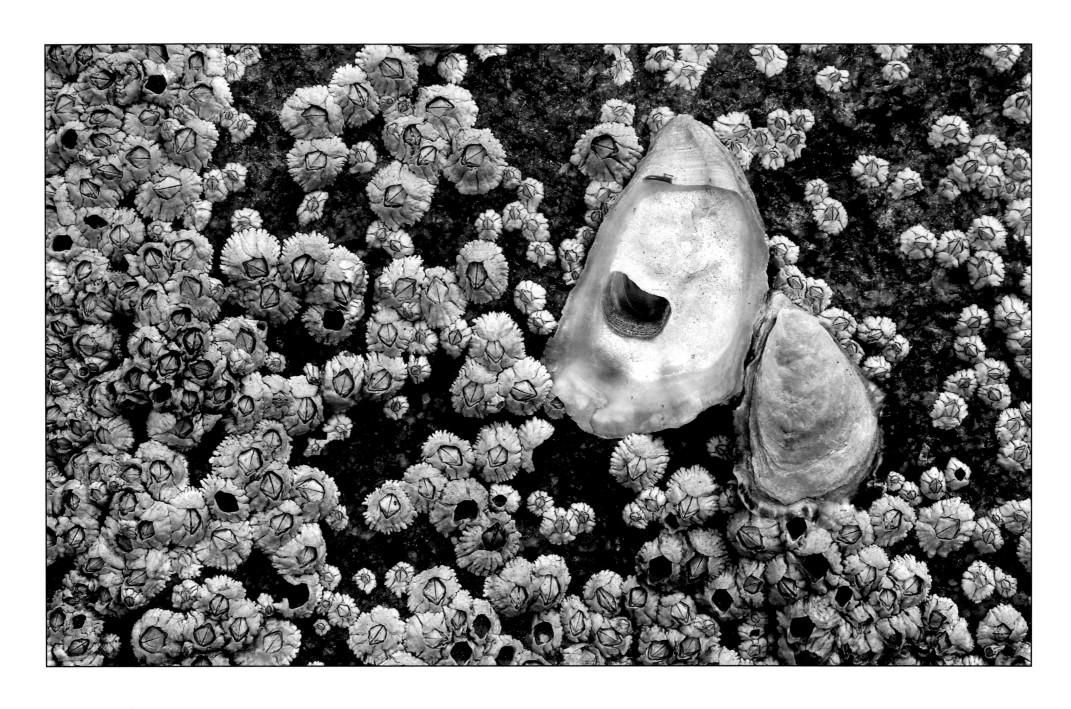

Barnacles and Oyster Shells

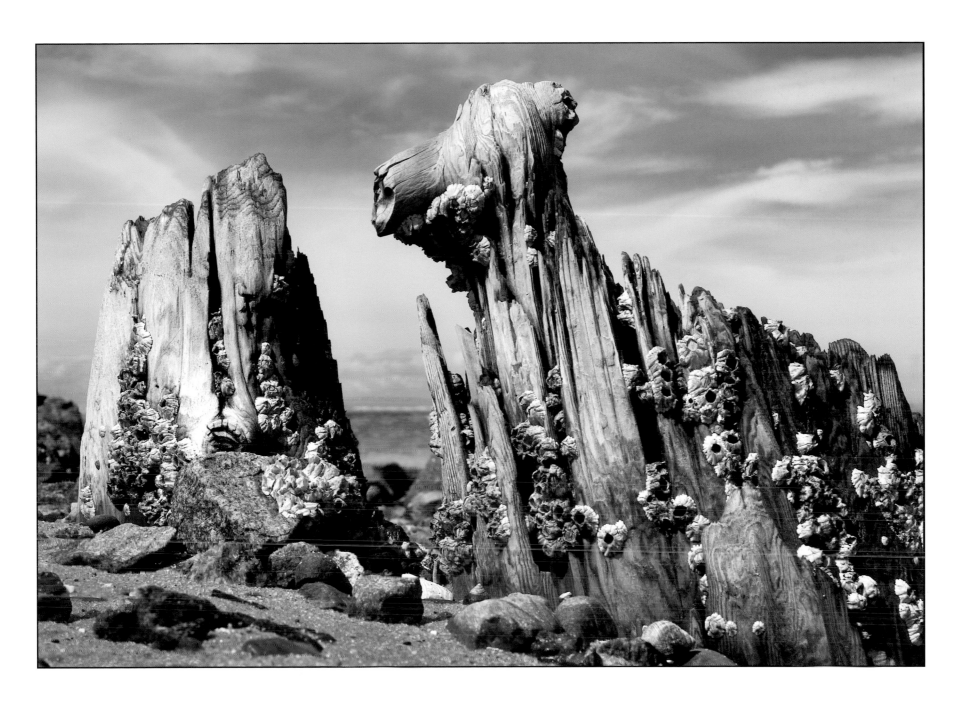

Old Railroad Pilings

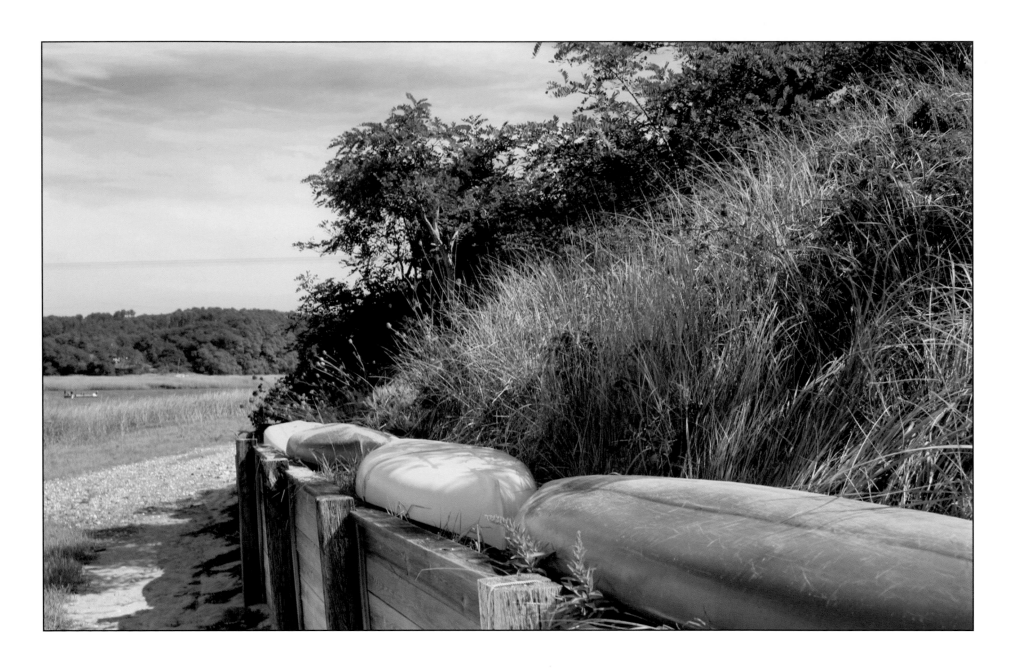

View from the Harbor

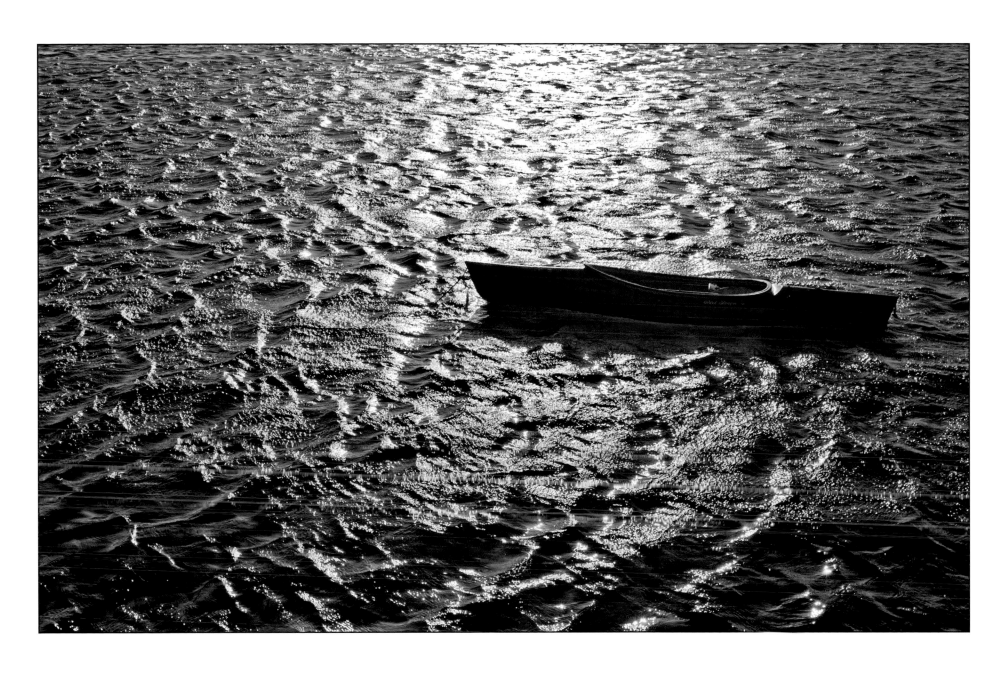

Kayak

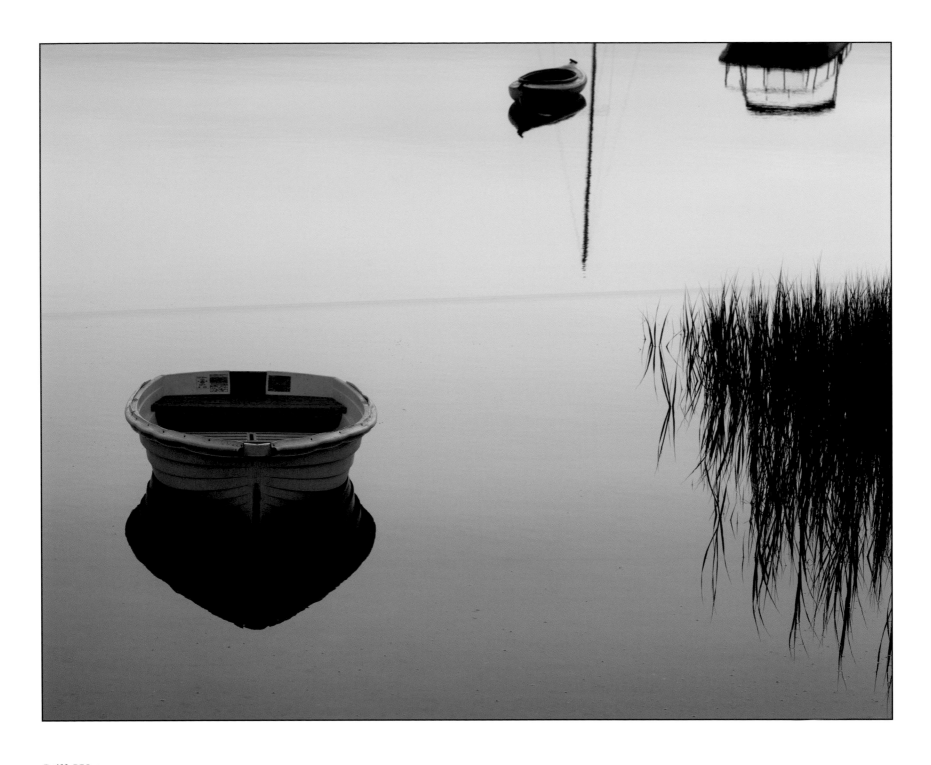

Still Water

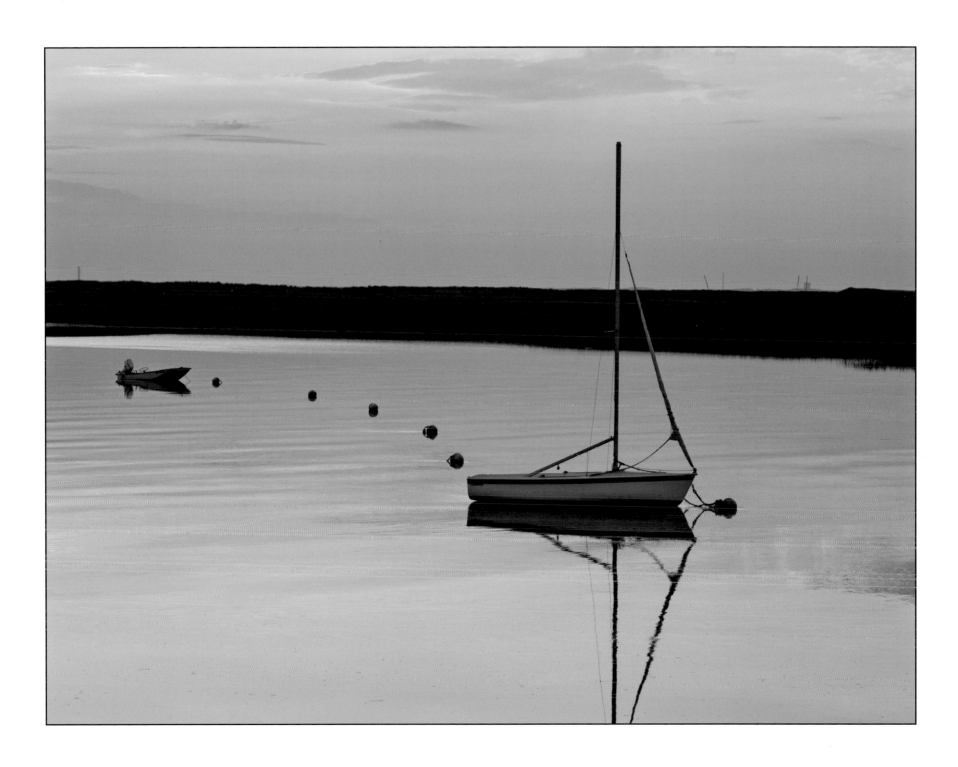

Moorings

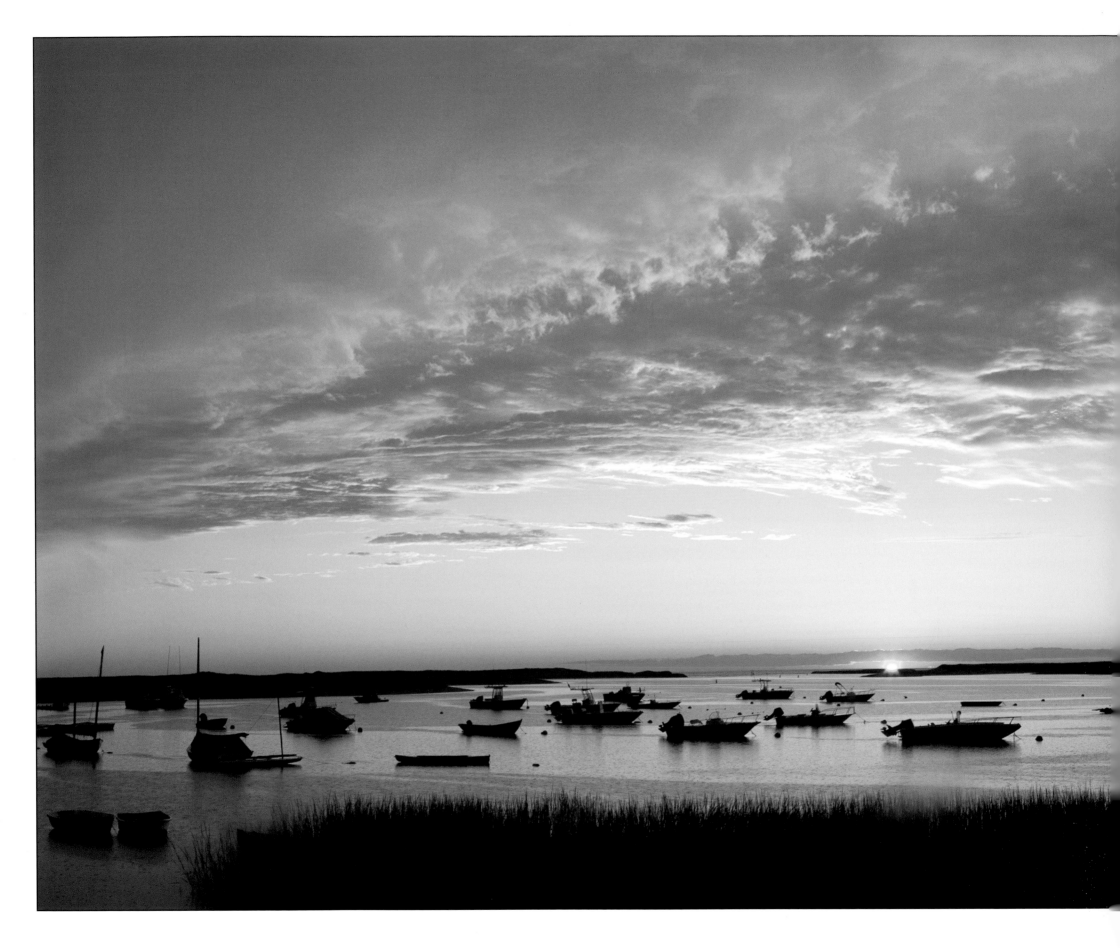

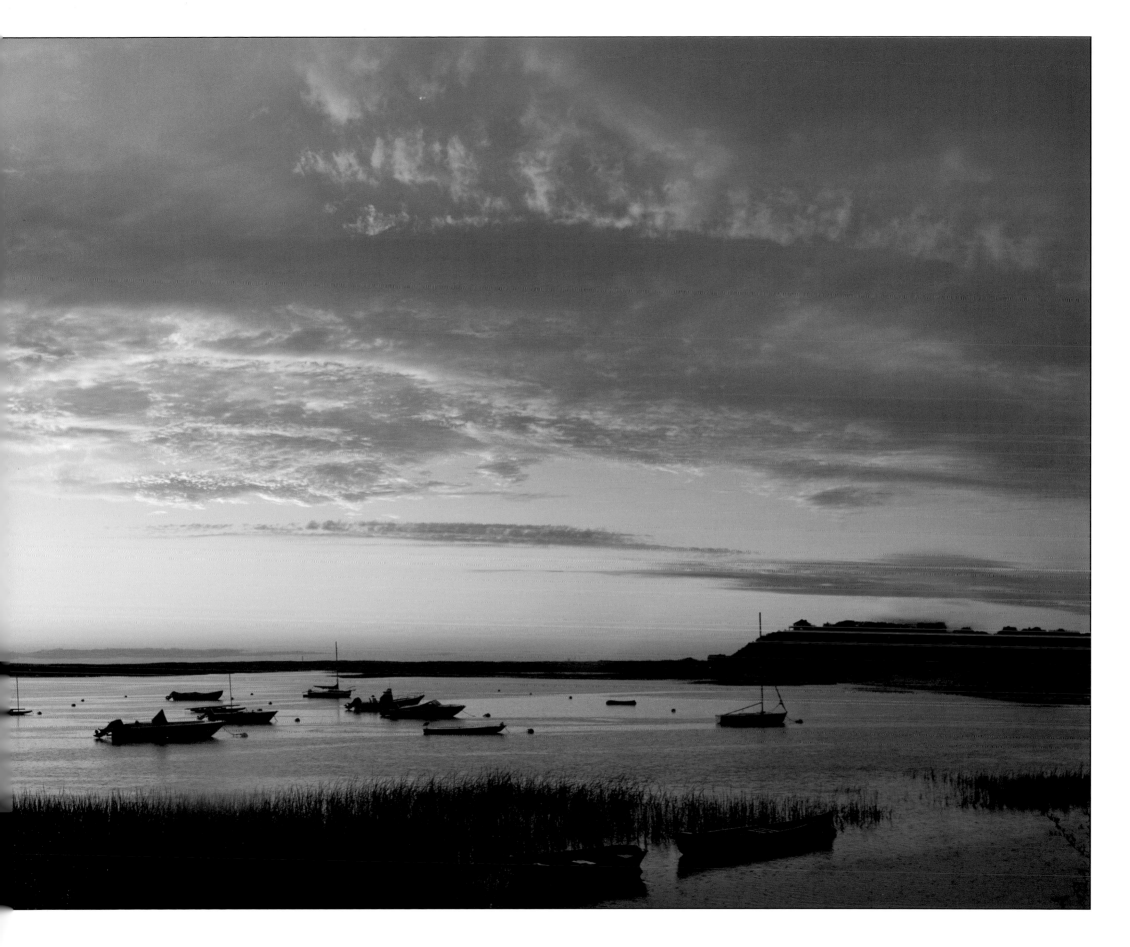

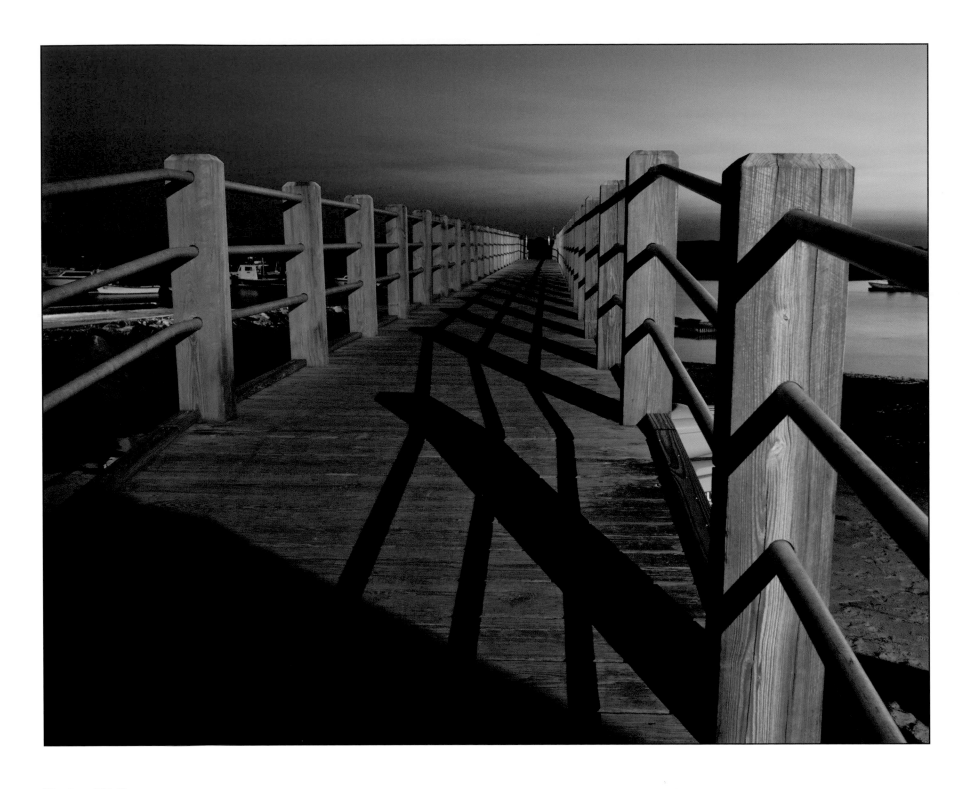

Harbor Walkway

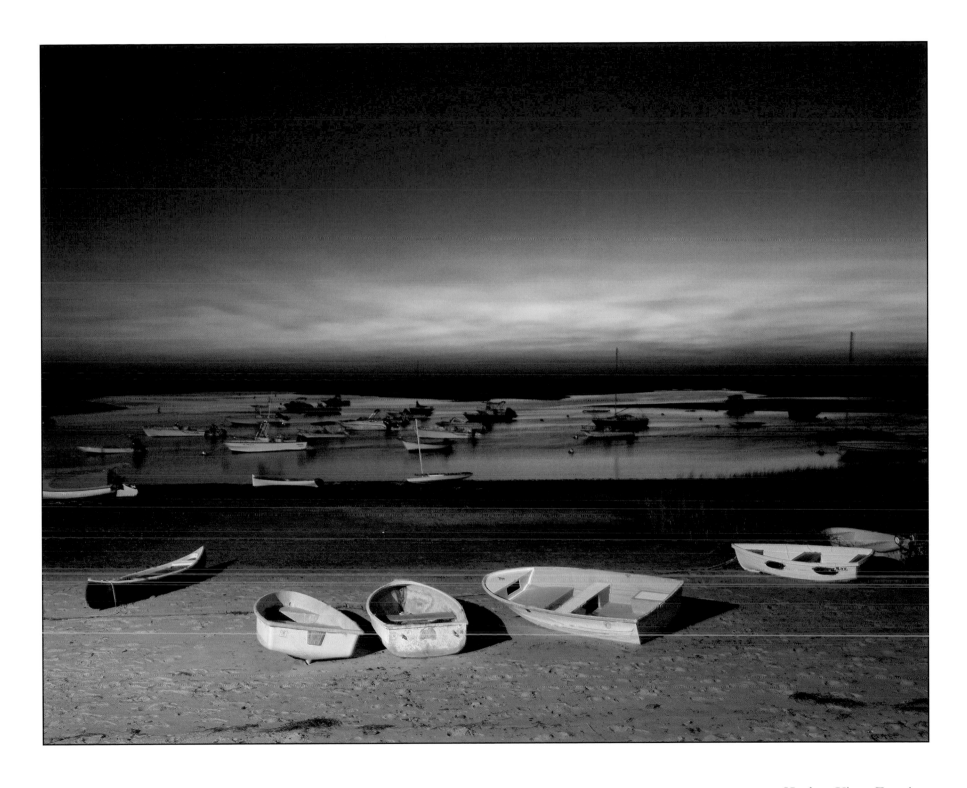

Harbor View, Evening

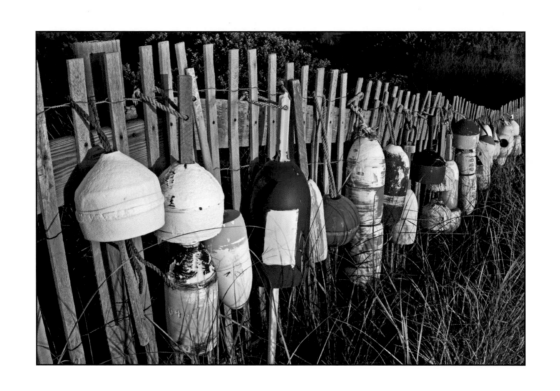

BAYSIDE

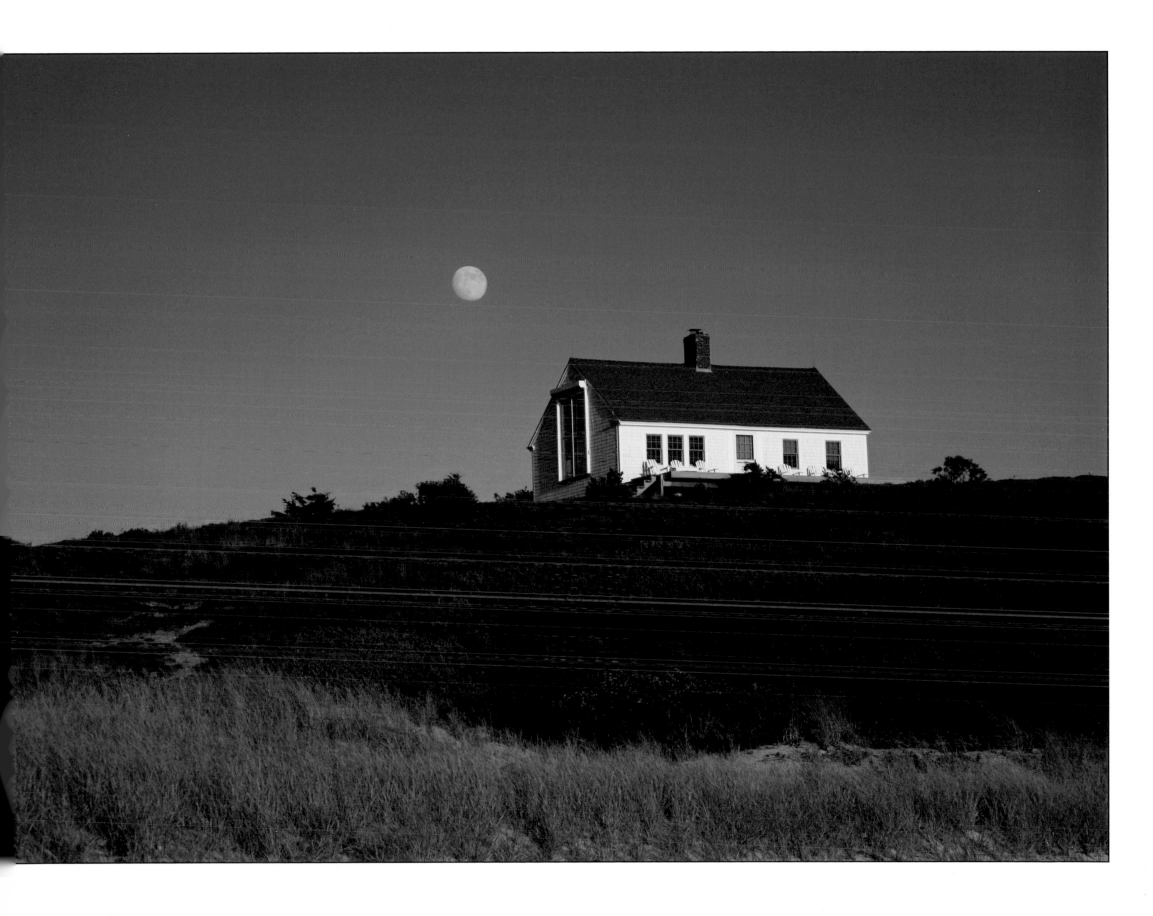

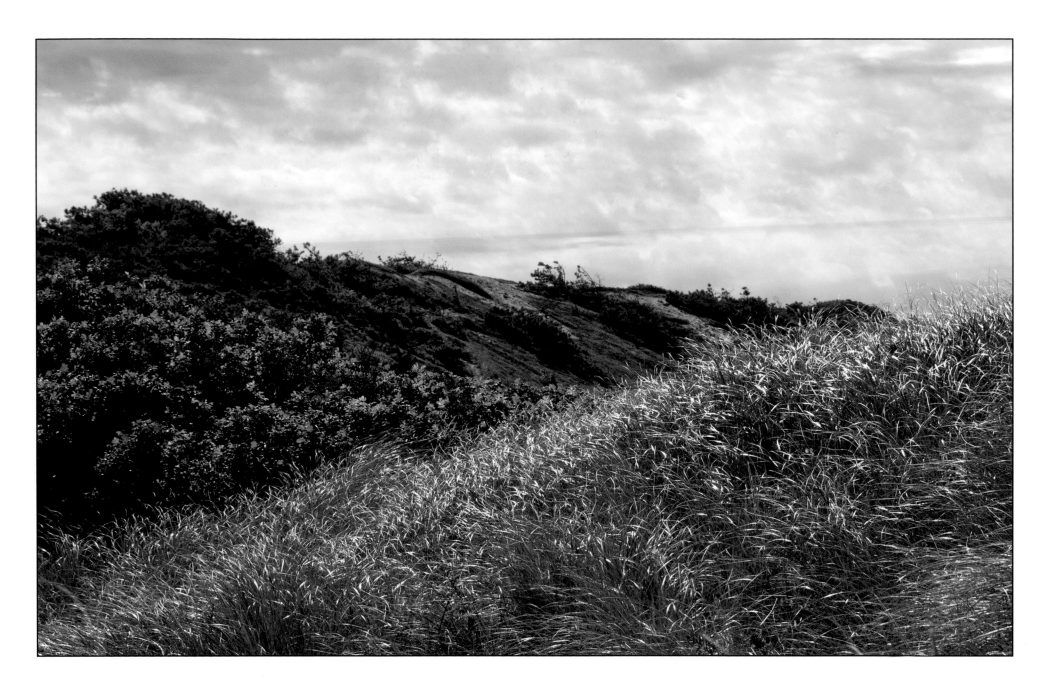

Corn Hill Grasses

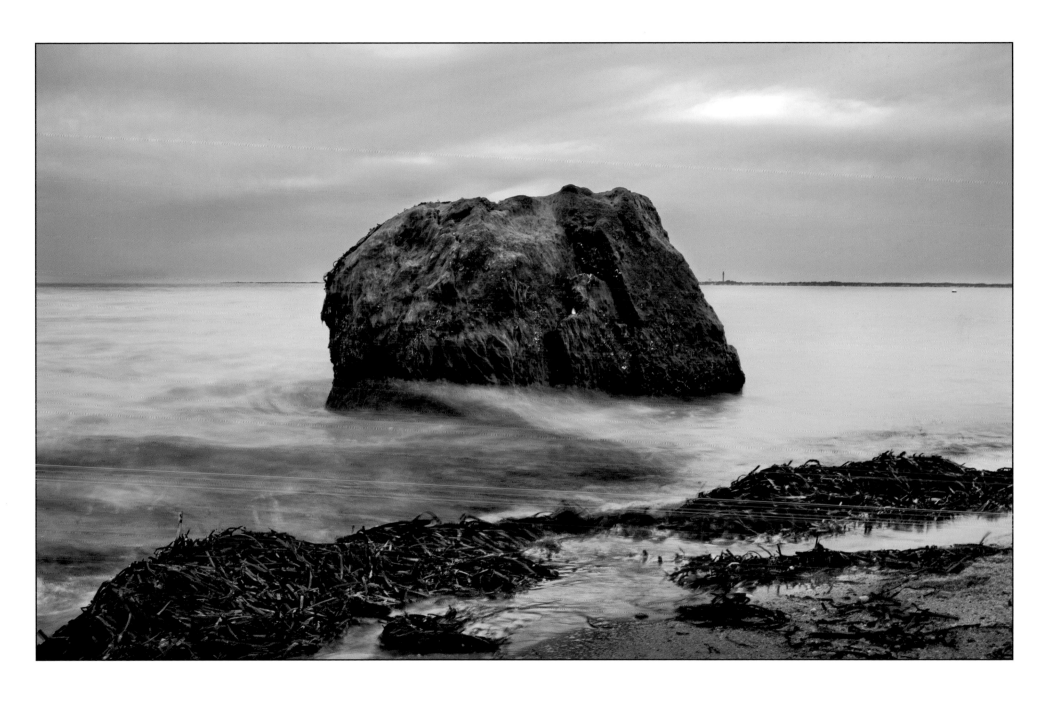

Exposed Rock

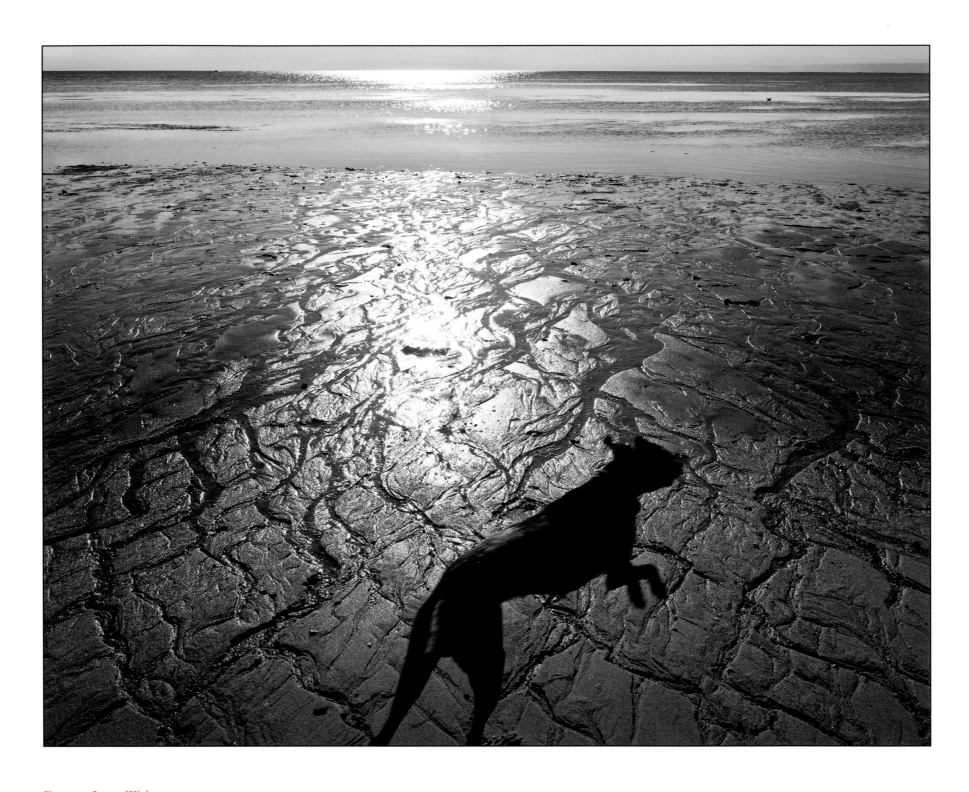

Dog at Low Tide

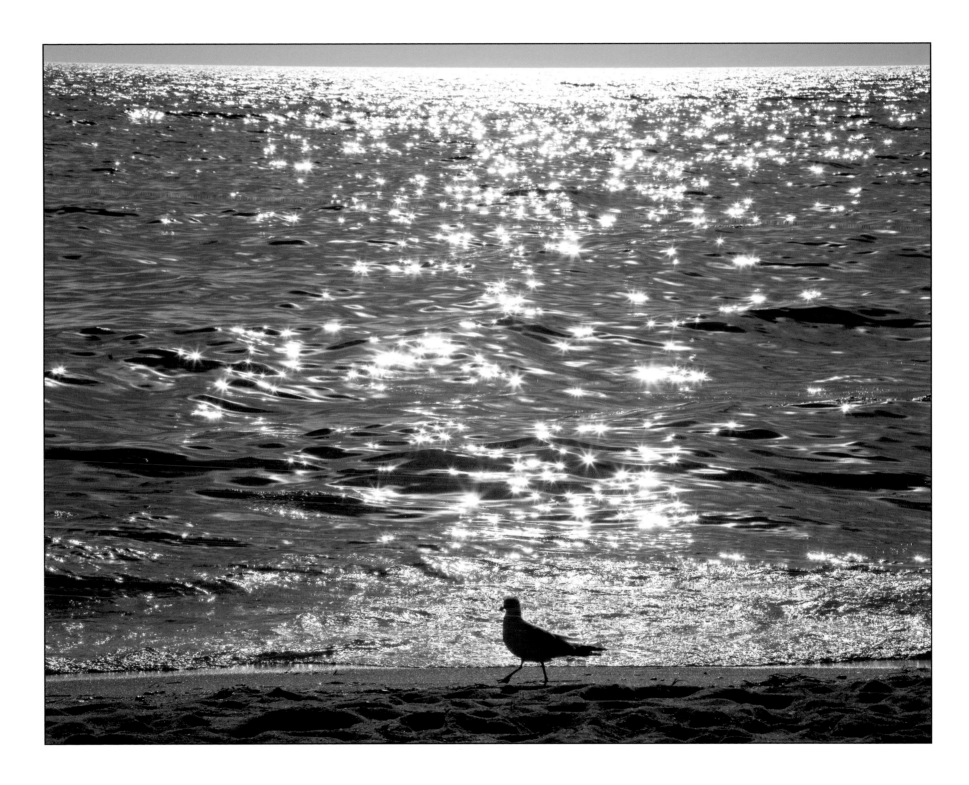

Gull Walking

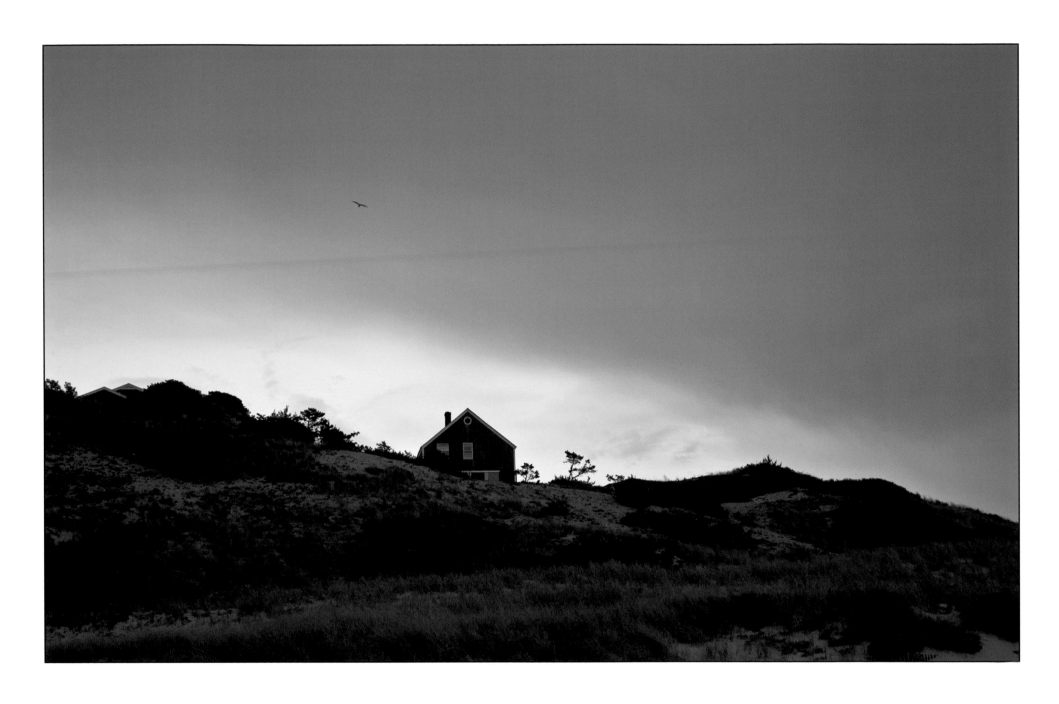

House on Dunes

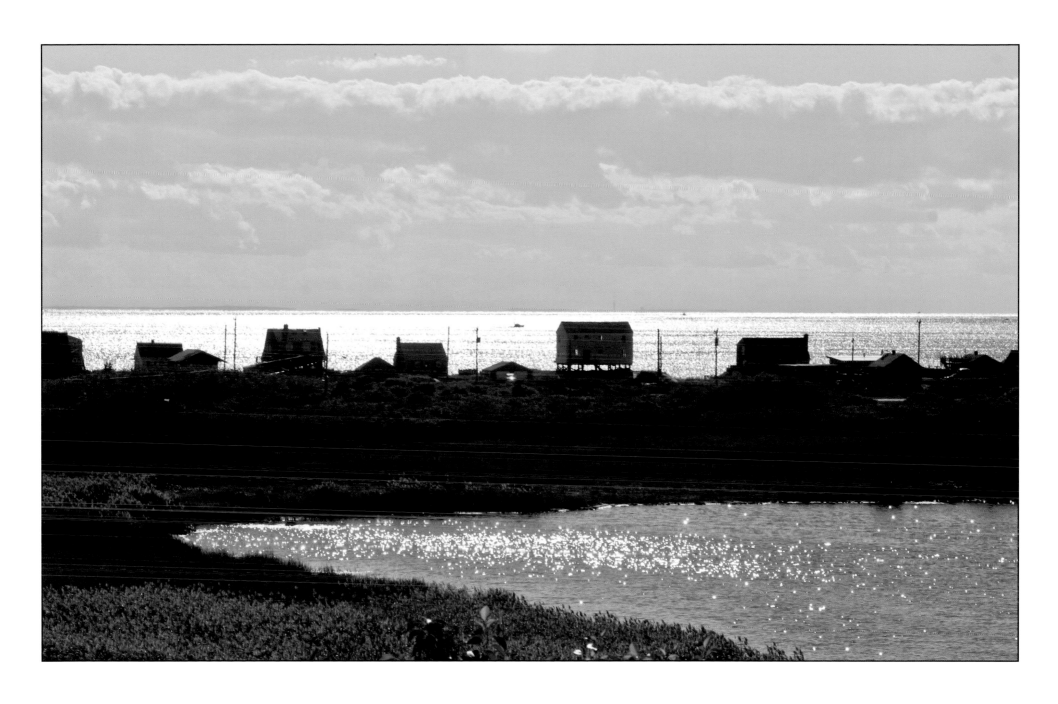

North Truro

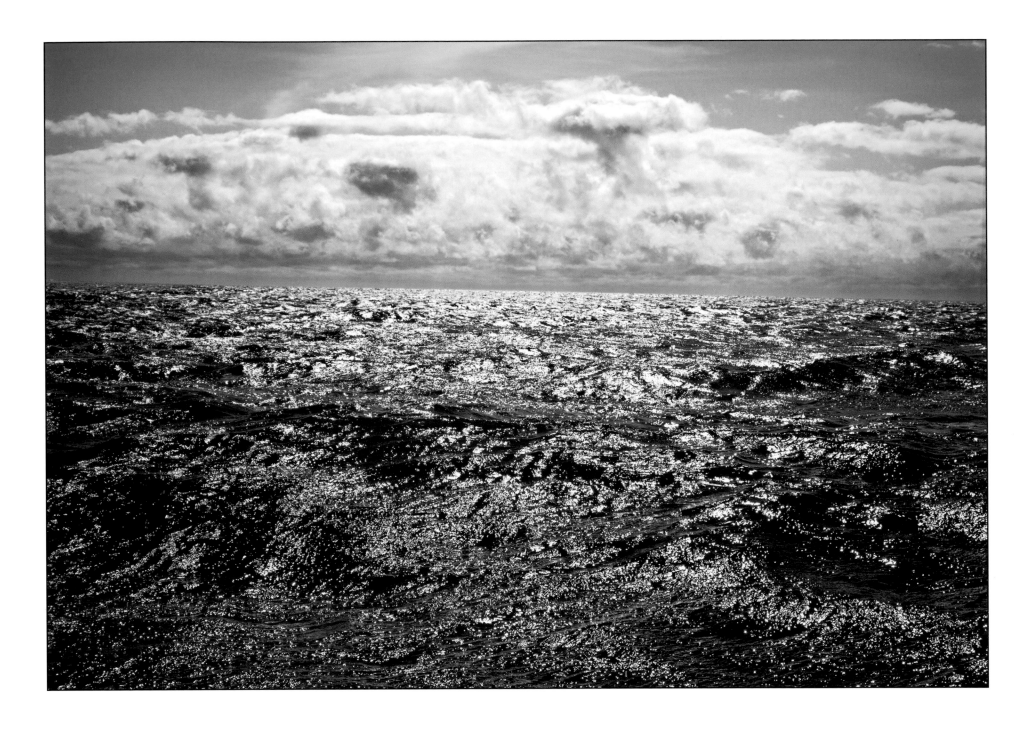

Turbulence

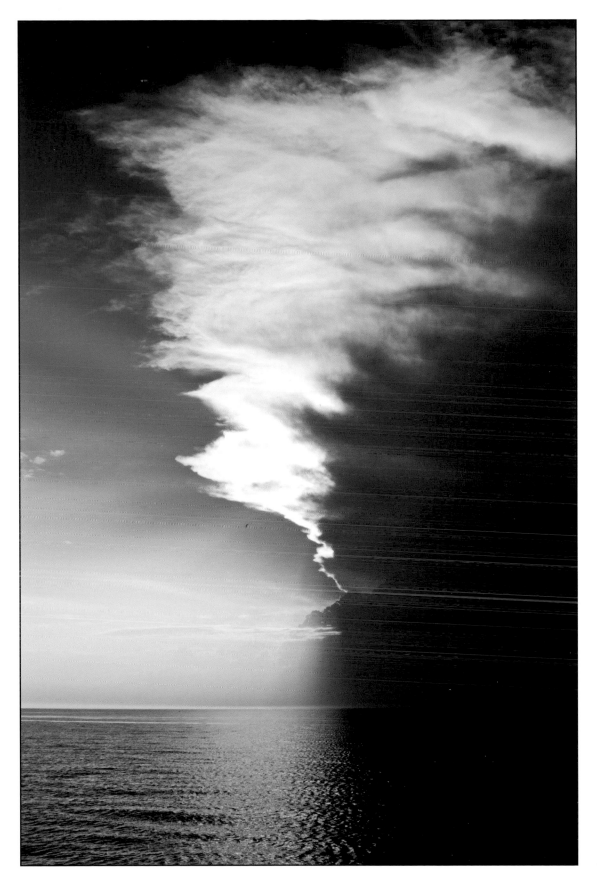

Approaching Storm

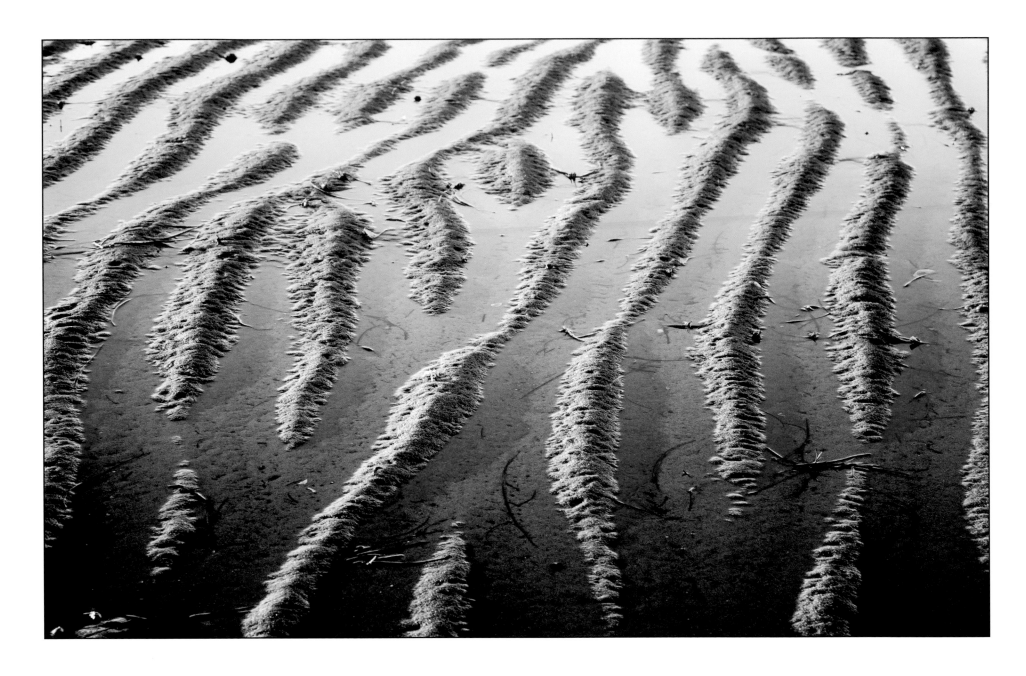

Sand Pattern IV

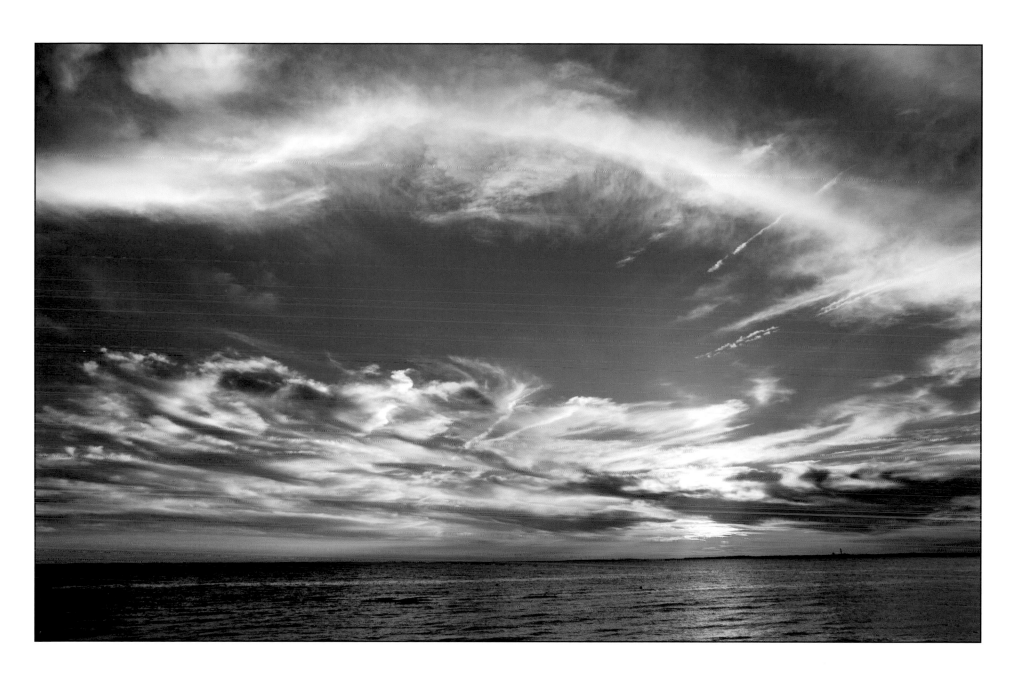

Clouds, Great Hollow

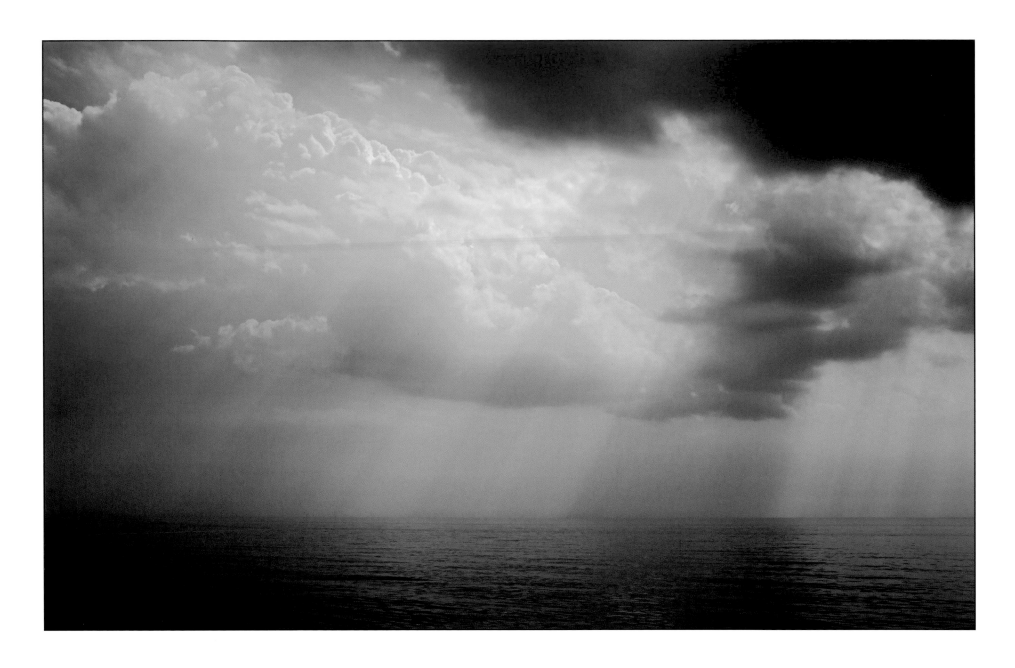

Light Breaking Through

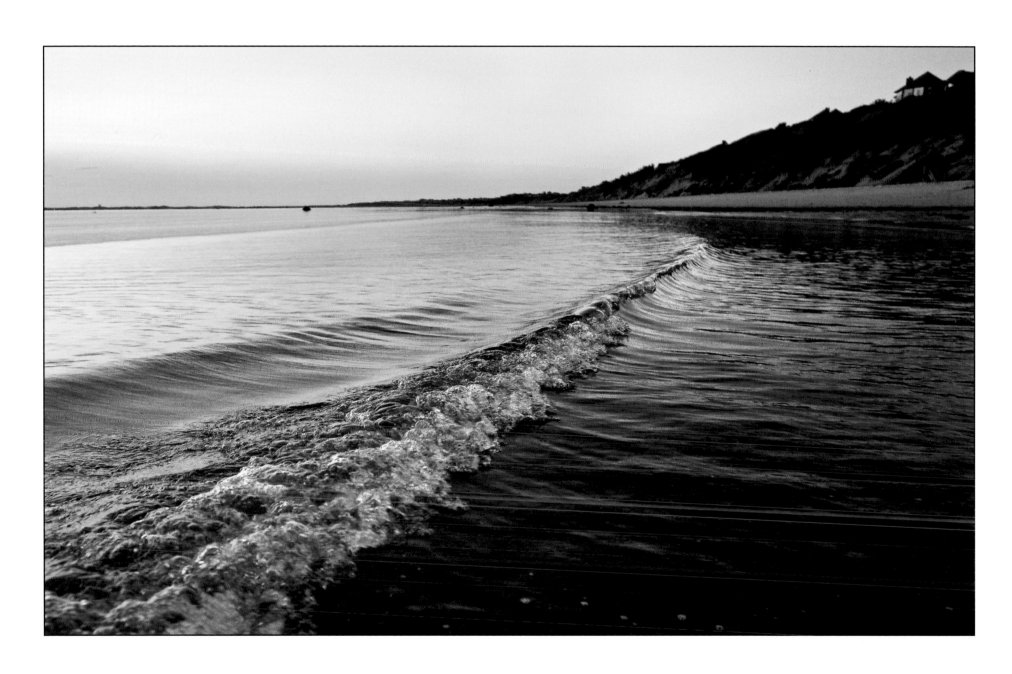

Wave at Sunset

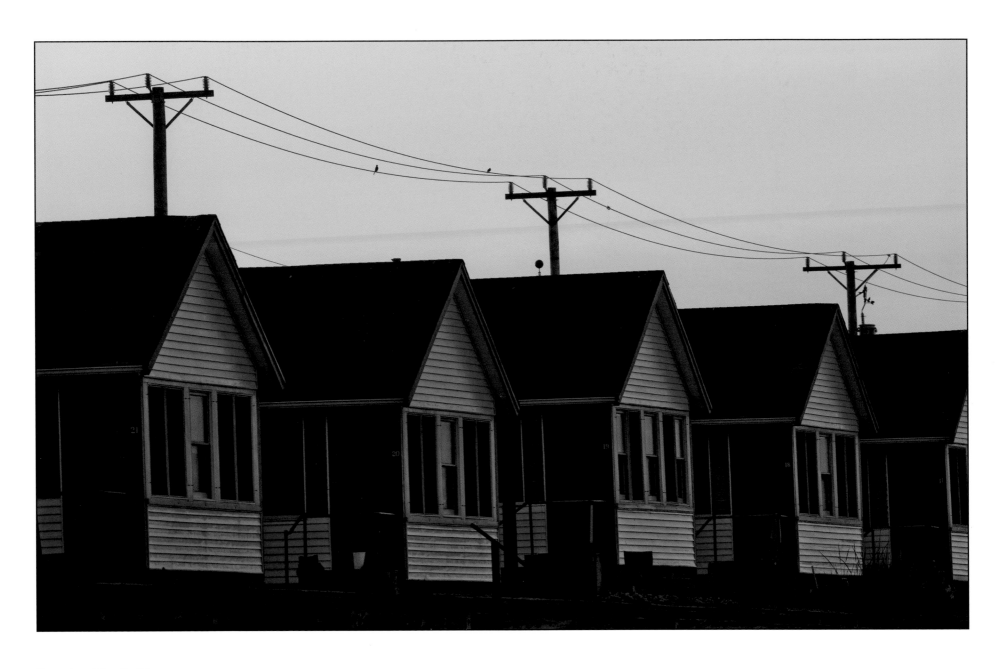

Sunrise, North Truro

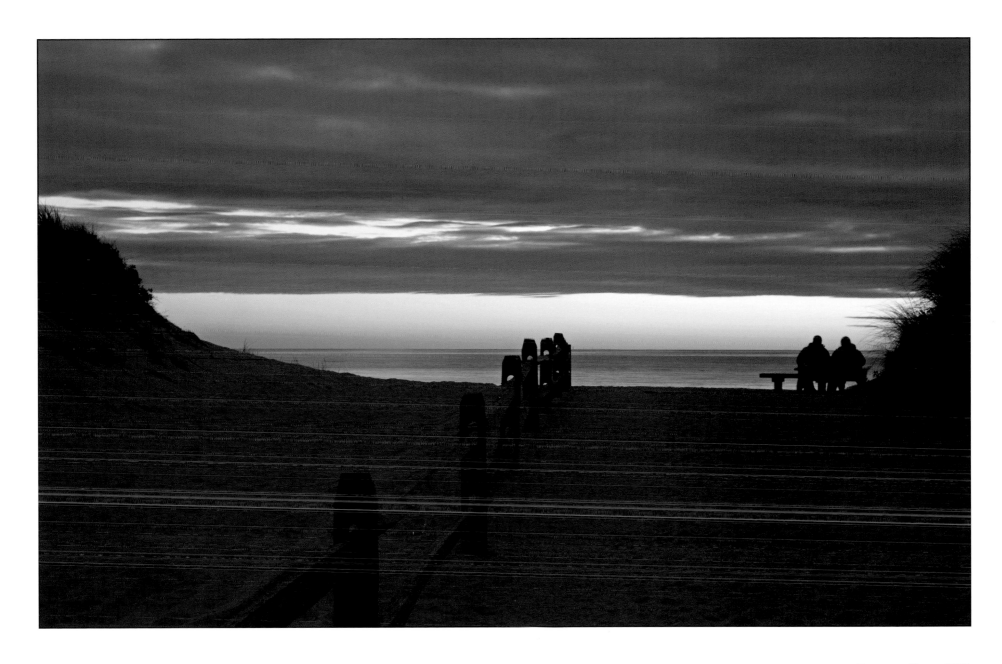

Sunset, Corn Hill

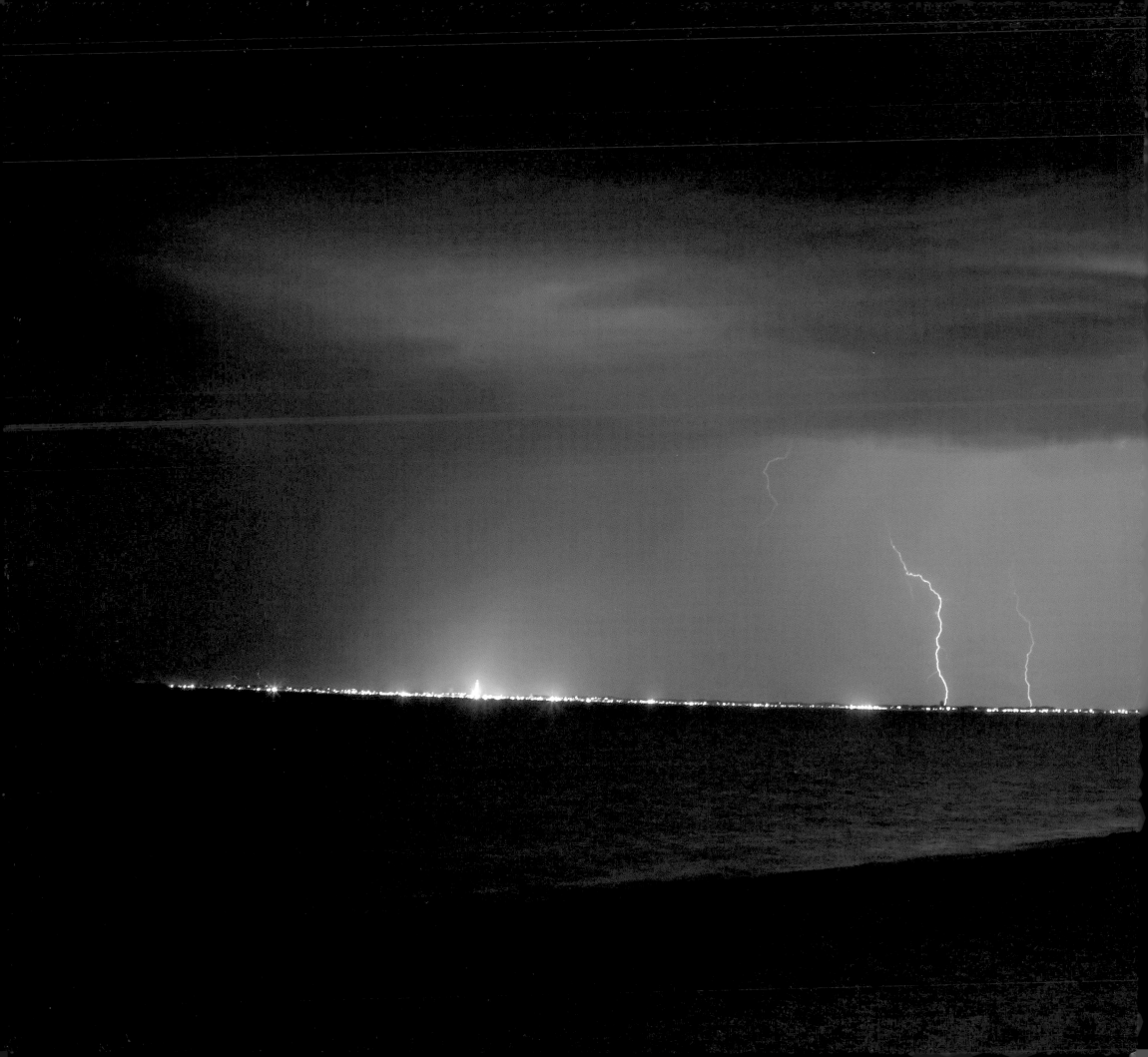

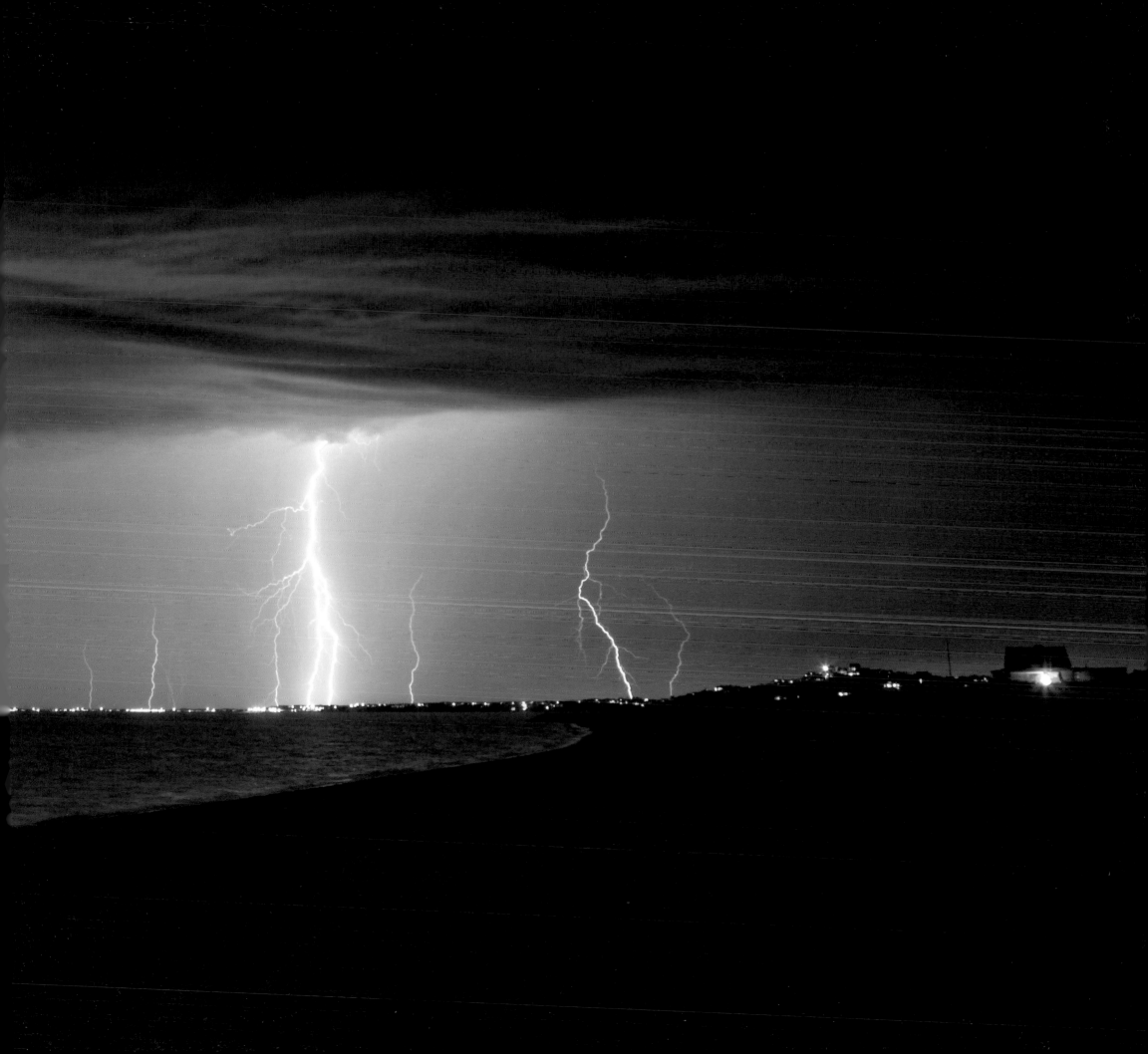

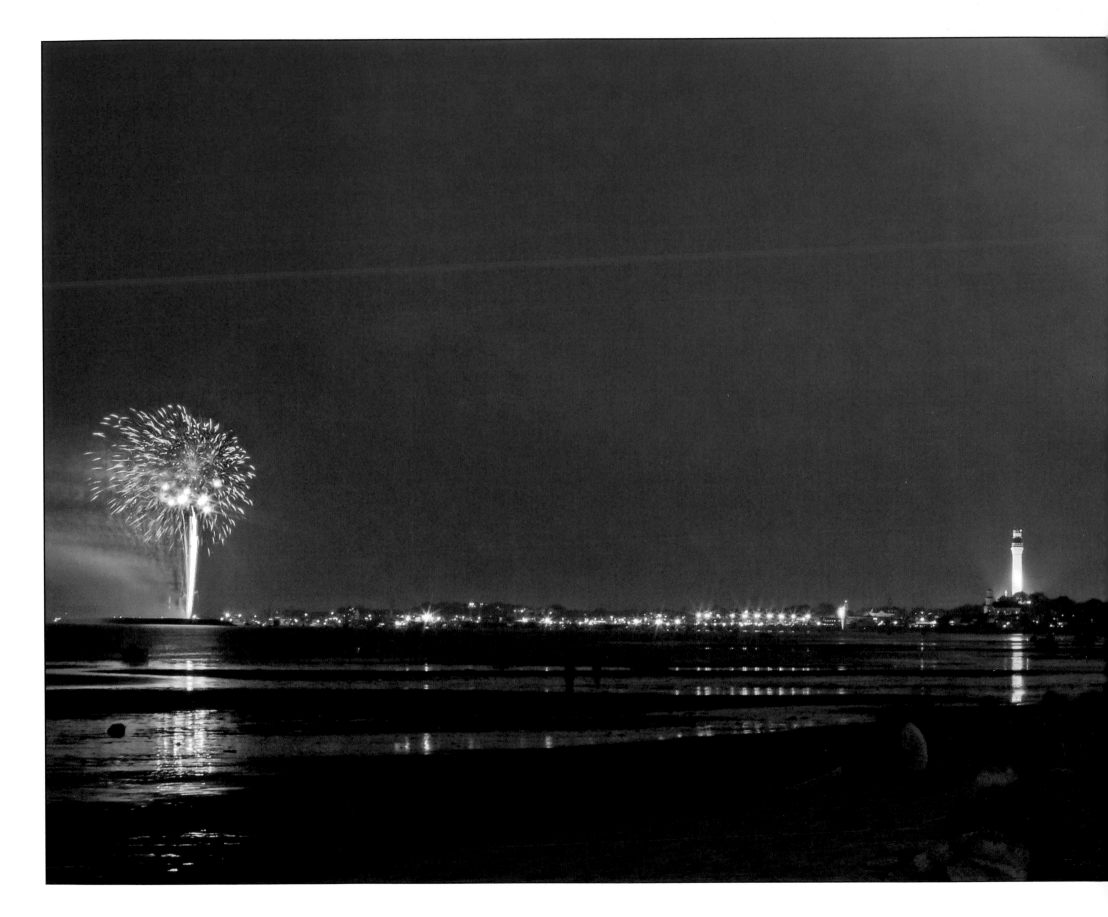

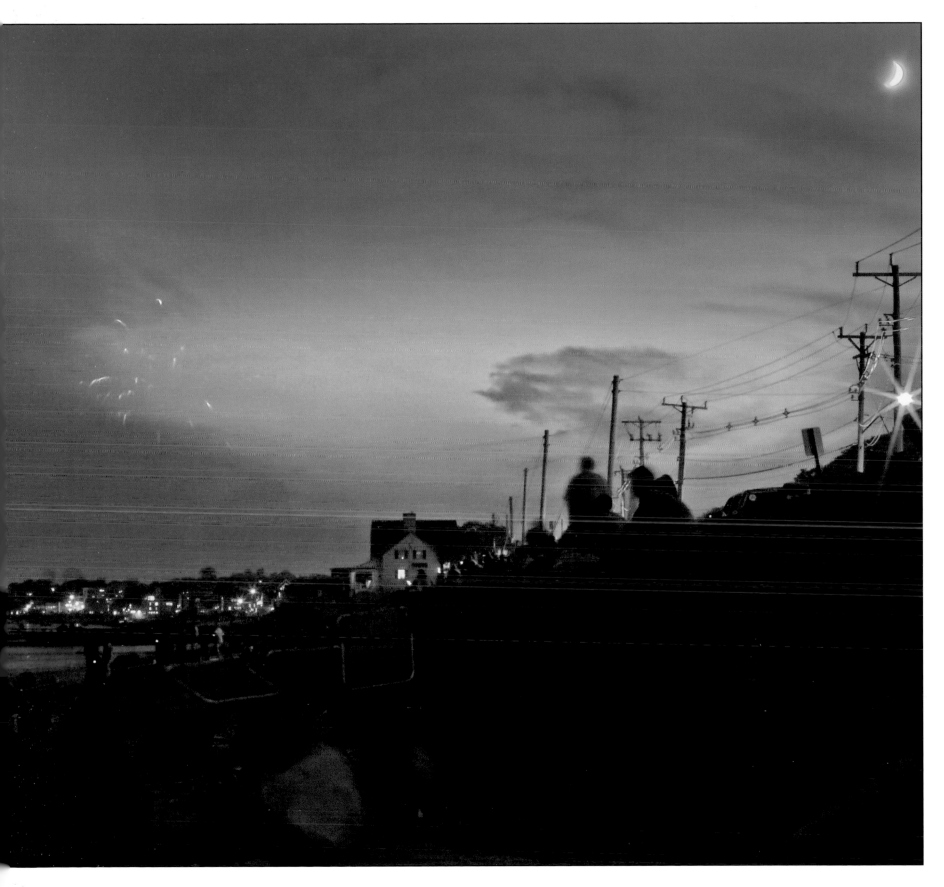

Fourth of July

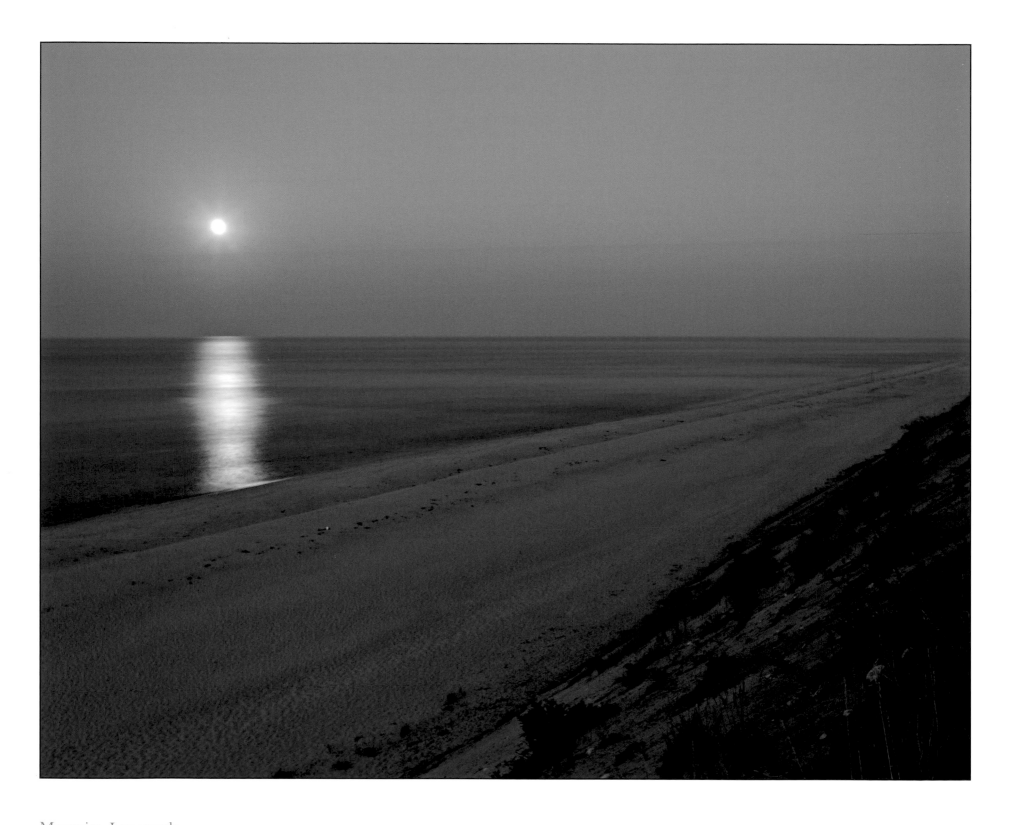

Moonrise, Longnook

Dedicated to the memory of Helen & Herman Rasker

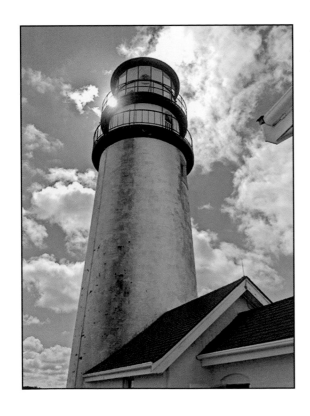

ACKNOWLEDGMENTS

I wish to thank the following people for their support and collaboration in making *Truro Light* a reality:

Eileen Schuyler for shepherding the project all the way through, especially for the sequencing of photographs and the overall flow of the book.

Charles Fields Publishing: Charles Fields for agreeing to publish the book and his enthusiastic response throughout the project and Gail Fields for her patience, generosity and experience in making the final design.

Glenn Bassett for his keen and sensitive eye for color and detail in translating the photographs for the printing press, and his deep understanding of how best to bring them to life.

Tricia Ford at Truro Library for guiding me to Charles Fields Publishing.

Cammie Watson for offering an insider's knowledge of Truro, and for her kind words about the book.

Peter Turnley for his thoughtful comments, and for serving as an inspiration.

—Joseph Schuyler